AUG - 1 1995

DAVID CARR

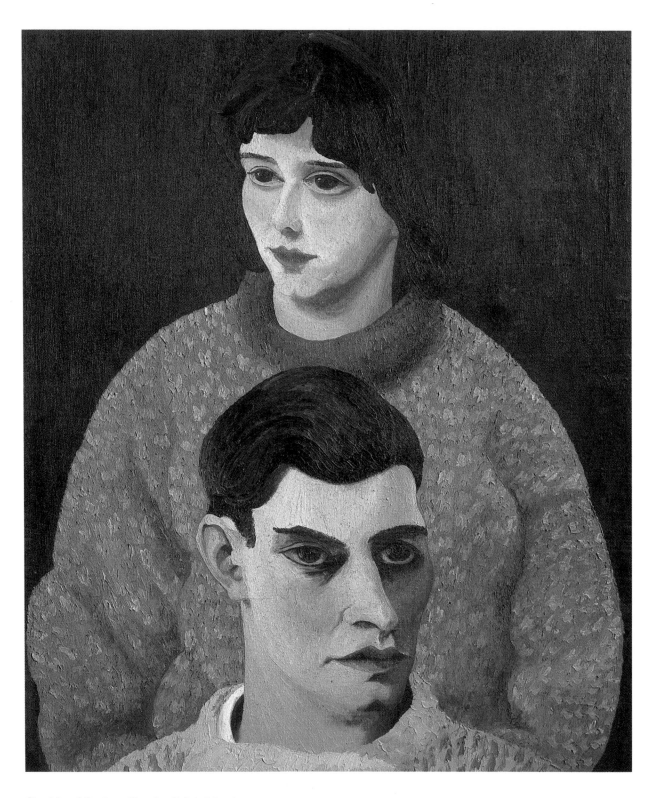

David and Barbara Carr by Cedric Morris

DAVID CARR
The Discovery of an Artist

Quartet Books
London New York

First published by Quartet Books Limited 1987
A member of the Namara Group
27/29 Goodge Street, London W1P 1FD

Illustrations copyright © 1987 by the Mayor Gallery
Text copyright © 1987 by the Individual Contributors

British Library Cataloguing in Publication Data

Robertson, Bryan
 David Carr: the discovery of an artist.
 I. Carr, David, *1915-1968* — Criticism
 and interpretation
 I. Title II. Alley, Ronald
 759·2 ND497·C37/

 ISBN 0-7043-2633-7

Origination by York House Graphics Limited, London
Typesetting in Ehrhardt by The Text Unit, London
Printed in Great Britain by
Farringdon Printers, London
and bound by The Camelot Press Limited, Southampton

ACKNOWLEDGEMENTS
The publishers would like to acknowledge the following:
Sherman Carroll; A. C. Cooper, photography; the Tate Gallery,
London, for permission to reproduce the painting of
David and Barbara Carr by Cedric Morris; the Victoria and
Albert Museum; Sarah Hargreaves

For Barbara Carr

'... I want to make a name for myself.
I have a horror of sinking into oblivion'

David Carr, from a letter to his mother

CONTENTS

THE PLATES

THE DISCOVERY OF DAVID CARR

Akumal Ramachander

After the television programme *The Painter and the Pest* was shown, documenting the discovery of Harold Shapinsky, Patrick Carr's letter was one of the many I received requesting me to see the work of unknown artists. For some reason, however, my initial response to his letter was one of silence. It was in January 1986, when David Chambers and his wife visited India, that I happened to show them Patrick's letter which had been lying on my table, unanswered, for over six months. The Chambers were intrigued by it and, luckily, as I was later to discover, I gave them his address and telephone number so that they could contact him on my behalf and apologize for my strange silence. They were to see him in London and reassure him that I would be visiting England in the Spring.

After many weeks of silence, it was chancing upon Richard Cork's review of Ronald Alley's exhibition 'Forty Years of Modern Art 1945-85' at the Tate, which reminded me that I had promised Ronald I would certainly be in London for this, his swan song. And so in March 1986 I once again found myself in the Tate Gallery. It was here in early December 1984 where I had first met Ronald Alley and shown him slides of the work of Harold Shapinsky, the American abstract expressionist. I was staying with David Chambers, who asked if I was going to call on Patrick Carr. For several reasons they had been too preoccupied to contact him themselves. Unfortunately I had left Patrick's letter in Bangalore, but David, of course, had the address and telephone number and asked me to do the rest. Since Patrick was later to tell me that his telephone number was unlisted, it was lucky indeed that I had shown his letter to David in Bangalore.

Patrick responded to my telephone call that evening with utter astonishment. He had waited for a reply from me in 1985 and had even telephoned Bandung Productions, makers of the Shapinsky film, to check that they had forwarded his letter to me. Having heard nothing, he had reckoned that it was now in the lap of the gods. The timing of the telephone call was equally fortuitous: he was to visit his mother in Norwich on 28 March and thought this provided a great opportunity for me to accompany him, meet his mother and see his father's work. After the journey we had lunch, and then Patrick showed me what seemed to be a treasure trove. Most of the paintings had not been touched or seen for over a decade and a half. Those of old Irish peasant women had a haunting quality which contrasted markedly with the

Man and Machine series, a superb chronicling of the uneasy relationship between man and machine. There were watercolours, sketchbooks, portraits, some abstracts as well as drawings and sculptures of New York.

Although I was very impressed by Carr's work, I needed someone of authority to confirm my opinion. I asked Patrick to transport half of his father's canvases to London and, happily, his mother agreed to this plan. While he remained in Norwich to make an appropriate selection of the work, I returned to London the following day convinced that this was a major discovery. When I asked Andrew Murray of the Mayor Gallery to come and see the work of an English painter, he thought I was joking. On being pressed, however, he agreed to visit Patrick Carr's flat in Barnes with Julia, his wife. I was to meet them there after going to the theatre with Patrick and Ronald Alley, thus completing the plan. When we arrived, Patrick gave us a few biographical details about his father and then showed us the paintings. Ronald, Andrew and Julia were all astounded. As Ronald said: 'His work is so good; how appalling he is not known.' Andrew wished to get the paintings to the Mayor Gallery where he could see them in daylight. Ronald, meanwhile, promised us 'all help' to make David Carr's work known in England.

So Patrick moved some of the paintings to the Mayor Gallery, and after seeing them in 'proper light' Andrew Murray reiterated his opinion of their quality. I showed the work to more of my London friends, and all of them were impressed. Since James Mayor was still in America, I had to return to Bangalore and wait. Ronald, however, was confident that things would work out. A month passed and nothing happened. In early May, therefore, sensing that something needed to be done, I returned to London. James was back from America but had been too busy to look at Carr's work, but on my return Andrew made a priority of showing it to him. James was quick to appreciate Carr's merits as a painter, and remarked: 'It seems to be a repeat of the Shapinsky story.'

More surprises were in store for James Mayor. He discovered that Bryan Robertson, regarded by many as one of England's most influential art critics, had actually known David Carr extremely well, and was also aware of some of his work. He was touched by the odd circumstances of Carr's rediscovery and agreed to write a critical piece on his work. I felt that all this deserved to be covered by television and contacted Greg Lanning, director of the Shapinsky film. He kindly suggested Anthony Wall of *Arena*. Anthony came to the gallery, looked at the paintings, heard my story and was convinced that there was more than enough material for a film. He, in turn, put me in touch with John Archer of BBC2, who lost no time in responding to my telephone call asking him to come and see Carr's work. He greatly admired what he saw and agreed to do something on the subject. From loving storage in a three-hundred-year-old house near Norwich, to a major exhibition at the Mayor Gallery – the discovery of David Carr's work had been made.

Akumal Ramachander

DAVID CARR

Ronald Alley

Although David Carr was quite a well-known figure in the art world in his lifetime, as a collector, visitor to exhibitions, co-founder of the Norfolk Contemporary Art Society, friend of artists and general enthusiast, his own paintings remained largely unseen and unknown. He was a serious, deeply committed artist and painted full time, but he only very rarely showed a picture or two in a mixed exhibition. His first one-man show (at the Bertha Schaeffer Gallery, New York) did not take place until March 1969, four months after his death, and was of abstract drawings made right at the end of his life; and even the exhibition put on by the Norfolk Contemporary Art Society in his memory at the Castle Museum, Norwich, in 1972 included nothing from before about 1950. Yet his early figurative paintings are very intense and extraordinary, and constitute a real discovery.

Carr was born on 2 November 1915 in London, the son of a wealthy biscuit manufacturer, and he was educated at Uppingham. On leaving school in 1934 he joined Peek Frean's Biscuits, the family business, but soon found that he hated the work and in 1936 was given leave to go to Exeter College, Oxford, to read History. However, he also began to paint in his spare time, and announced in May 1937 that he had decided to leave the family business altogether and study painting. His father was furious, but his mother, who was herself a painter, supported him; so, after taking some preliminary drawing lessons at the Byam Shaw School, he was able to enrol in 1938 in the East Anglian School of Painting and Drawing run by Cedric Morris and Lett-Haines. The earliest painting of his that I have seen, a view of a beach with holiday-makers, clearly painted on the spot, shows the influence of Cedric Morris in its rich fatty paint and painterly handling.

The students at the school included Lucian Freud and Barbara Gilligan, who later became Carr's wife. (A double portrait by Cedric Morris of David and Barbara Carr is now in the Tate Gallery.) Lucian Freud was only sixteen when they first met, and David Carr has left some amusing reminiscences of him at this early stage of his career. Moreover, either Carr or Freud may have been responsible for accidentally setting fire to Cedric Morris's Dedham painting school in July 1939. They had both been painting late and smoking, and the school caught fire and burnt down during the night. It was after this that Morris moved to Benton End.

Carr left the East Anglian School at the end of 1940, but continued to keep in

close touch with Cedric Morris and particularly Lett-Haines, and to bring his paintings in from time to time for criticism. As a Quaker, he volunteered for service in the merchant navy or to drive an ambulance in London, but was turned down on medical grounds. He was therefore able to continue painting throughout the war, though from 1942 only in his spare time while working on a farm in Somerset. In addition he started to buy works by other contemporary artists and to form what was to become a very choice collection. Having bought his first Lowry from the Lefevre Gallery in June 1943, he wrote to Lowry himself a few months later, and this led to their meeting and a warm friendship developing between them. According to Lowry's biographer, Allen Andrews, 'David Carr was the first *artist* with whom Lowry built any relationship based on mutual regard.' Lowry was greatly touched by the young man's enthusiasm for his work and by his real understanding of it.

In his first letter, written in December 1943, Carr told Lowry: 'For the last few years I have been working on the same style of landscape as yourself, and being a holder of an MOI permit ... have had good opportunity for exploring the so-called hideous parts of London, Ipswich and Bristol, concentrating almost entirely on the dock areas of those towns. But, unlike you, I try to express my feelings through the buildings alone; the boats, the cranes, the railway trucks are the monsters who live in my world and people it.' However within a few months he had also begun to paint interiors, which Lowry found particularly interesting.

All the works reproduced in this book seem to have been painted after 1944, even the quaint and amusing little picture of Carr himself in the bath, as it shows the bathroom at Starston Hall in Norfolk to which he moved at the end of that year. As very few of these pictures were exhibited in David Carr's lifetime, and as none is dated, it is sometimes difficult to place them in sequence and to establish the exact order of the various phases. What seems clear however, is that he no longer painted directly from nature but from memory or imagination, and that he sometimes worked out the compositions beforehand in precise, linear pencil drawings. By the end of 1945 he was able to tell Lowry that he was working hard and that ideas were toppling over each other. Lowry for his part encouraged him to look for eccentric human types and to paint 'queer' pictures.

Figures now began to play a major role in his work, close up in exterior or interior settings, and his subjects were usually working people such as a fishmonger standing behind his barrow of herrings or a man in a cap with a funny little dog on a lead. Several of the pictures of this type were based on scenes at Lowestoft, but others have a distinctly Irish character and seem to have been inspired by two visits to Ireland in the summers of 1946 and 1947, from which he brought back material for paintings. Particularly striking among them is a small series of pictures of old Irish peasant women in shawls: women with huge, linear, gaunt mask-like faces (and sometimes not much torso) seated behind tables on which there are beautifully painted still lifes of jugs, half-empty milk bottles, eggs and the like. This type of composition with a

figure, or figures, with a large head in a stiff, frozen pose seated behind a table with dominant still-life objects may have been suggested to some extent by the pictures Lucian Freud had been painting shortly before.

It is hardly surprising therefore that David Carr also became very friendly in the later 1940s and 1950s with Colquhoun and MacBryde, who shared his interest in a formalized depiction of Celtic peasant folk, and with Prunella Clough, who was painting pictures of East Anglian fishing ports, cooling towers and slag heaps, sometimes with figures of workers integrated into the compositions. The influence of Colquhoun is unmistakable in the later of his two pictures of work in a biscuit factory (no doubt a memory of Peek Frean's) painted about 1950, and seems to have served as a transition to his subsequent more strongly-constructed style.

The theme which now began to preoccupy him and which runs through all his later figurative works was that of man and machine: not just the beauty and power of machines but their role as the physical extension of our living human bodies. He was seeking, as he explains in an unpublished typescript, to paint the fusion of 'the man and the machine ... into one new and nameless form ... [so that] the machine has become part of the man, and the man part of the machine'. Taking his inspiration from what he could see in a local workshop for repairing agricultural tractors, he depicts a mechanic, always just one individual, working on or with a piece of machinery in such a way that their forms combine together and even seem to be of the same metallic substance. The colours are almost monochromatic. As the series progressed, the forms, now post-cubist, gradually became more and more complex and broken up, until about 1954-5 he started to offset them against a simpler, plainer background; and this is the treatment which characterizes his last figurative phase.

His change to abstract art, to which he was getting quite close in any case, took place towards the end of the 1950s under the influence of the new Spanish abstract painters. He began to collect pictures by Tàpies, Millares and Saura, and made a series of large abstracts on hardboard using acrylic paints and with textures incorporating sand, ash and other such materials. As his abstracts fall outside the scope of this book, let me say simply that his later abstract work includes a large number of drawings in watercolour or pen and ink, including series on related themes which he bound together in albums. In 1960 he learnt that he was suffering from cancer, but he fought against his illness for another eight years and lived on until 28 November 1968.

As Eric Fowler wrote in the catalogue of the memorial exhibition organized by the Norfolk Contemporary Art Society: 'David was elected in 1958 to the office of president, and later vice-president, but his advice on the choice of pictures, and his energy in helping to arrange exhibitions, continued to be invaluable. He was not only a fine artist himself: he was a great friend to his brother artists. And he was so modest about his own work that very few people, even in the society he founded, knew or appreciated what he was doing.'

Ronald Alley

DAVID CARR

Bryan Robertson

David Carr was born in Wimbledon, London, on 2 November 1915, the family soon after moving to Petersham by the river between Richmond and Ham. His father, Philip Carr, was the titular head and chairman of the biscuit firm Peek Frean. The entire factory and office structure was based in Bermondsey but he and his wife, Marjorie Romer, of Huguenot descent, lived always at Montrose House, a well-known and quite grand example of domestic architecture of the William and Mary period, originally built and owned by the Duke of Montrose in the early seventeenth century. When the house was built and sited near the river its surroundings were wholly rural, but when David Carr was born, there were the beginnings of slight urbanization in the neighbourhood, although the big walled garden still kept a fair measure of privacy. Patrick Carr, David's eldest son, remembers visiting Montrose House as a child, with its spacious and immaculate lawns maintained in a state of pristine splendour, almost like putting greens. His grandfather was indeed a scratch golfer whose passion for golf and practically all other sports, including sailing with attendant cottage on the Isle of Wight, contributed to his zeal for an immaculate lawn as well, probably, as his eventual divorce from his wife. According to Patrick he was manic for sport with an eye for the ladies.

The Carrs of course came originally from Scotland, a strongly Quaker family from Carlisle. The family motto was *Tout Droit* – straight ahead. In 1857, a Mr Peek and a Mr Frean set up a business in Bermondsey manufacturing ship's biscuits. The biscuit business prospered, and eventually they decided to expand and manufacture sweet biscuits as well as the original provisions. They therefore formed a liaison with John Carr, a younger son of Carr's of Carlisle, another firm of biscuit manufacturers, and in time the Carrs inherited the Peek Frean business. Philip Carr was to all intents and purposes a Londoner. His family faith was strongly Quaker, verging on the puritanical, which kept him and his forebears and his immediate family away from the conventional professions, the law or the armed services or medicine. It was the family tradition to work inside the trade and business world, and to be more than competent in money matters.

David Carr spent his childhood at Montrose House, with its staff of gardeners, domestic servants, the nanny, a chauffeur-driven Bentley and solid Edwardian atmosphere of comfort, order and propriety based on three generations of monied

security. David was the third of four children, all boys. There were a few family portraits in the handsomely furnished house but otherwise, apart from conventional watercolours and engravings, there was no art of any kind in his everyday surroundings to arouse his imagination. At thirteen, after being taught by a governess, David was sent to Uppingham, in Rutland, to begin his formal education. There was an established family tradition for the Carr boys to attend this school. David detested the place and everything about it: rebellious and instinctively, temperamentally, unconventional, he hated the stiff routines, rituals and formal regime of the school. He showed no particular interest in art. In 1934, at eighteen, he left Uppingham and, without any strong affiliations or sympathy with anything else, entered the family business in Bermondsey.

David found the biscuit business as bothersome, bleak and unrewarding as life at Uppingham, and after a year, with carefully parted and back-groomed hair and dark suit, chafing at the office routine and the tight commercial milieu, he was sent to Paris for a year with a modest stipend to represent the Carr family business interests. He lived with a family in Paris and explored, in his spare time, the city and its environs. Little is known of this year in Paris except for one surprising fact that although, at nineteen, he became aware of huge cultural imbalances and deficiencies in his own taste and knowledge, he still did not react particularly strongly to art – apart from pleasurable if conventional visits to museums and galleries. Art was still remote. He had never travelled abroad before, either alone or with his family. At the end of the year, in 1936, he returned home and announced his intention to enter university, feeling strongly the need for cultural development and an urge to study the humanities. He would have done anything to avoid the family business, of course, but he also positively, actively, felt the need to equip himself mentally and to discover his own world.

A tutor was essential for a period of cramming to provide the necessary groundwork, and all this he managed on his own initiative, with only tacit support from his father. In 1936, he began his studies at Exeter College, Oxford, to prepare for a degree in history. He was at last in his element: talk, clamour, disputation, intelligent conversation, burning issues, coming war, the sociology of the period and a feeling of self-motivation, self-fulfilment, self-discovery. He formed a strong friendship with another undergraduate, Sidney Smith, a passionate art-lover, and travelled to Italy with him during a summer vacation. Italy brought the moment of truth through the crucial revelation of art. At last, David saw Italian art and architecture for the first time and knew at once that he must be an artist. He hadn't left England apart from his solitary year in Paris.

He was so positive about becoming an artist when he returned from Italy that he at once relinquished his place at Oxford after completing only four terms. Confronted with the ultimatum that his son not only never wanted to see the family business again but had every intention of commencing his studies as an art student without

delay, David's father immediately cut him off financially and even disinherited him. It was only the sympathetic intervention of his mother, herself a modest artist, who subsidized him privately and moderately for the next several years, until his father relented partially, that made it possible for him to realize his ambition.

In 1939, after a term in London at the Byam Shaw School where he studied drawing for the first time, David enrolled – enterprisingly and rather dashingly – at the East Anglian School of Art, run by the partnership, celebrated in later years, of Cedric Morris and Lett-Haines. Another student, enrolling a term later, was Lucian Freud. They became friends, but David had been led to the school through a different friendship – with the girl whom, in 1942, he was to marry, Barbara Gilligan. Earlier in the thirties, Barbara had studied at the Slade and she met David in 1938 through her sister, Bridget, who had been staying with friends in the West Country. David was staying in the same house: after his break with Oxford, he had been seriously ill following a bungled tonsils operation, and he was recuperating. Separately, David's mother had bought a house for family holidays near Southwold and Walberswick. Soon after meeting David in the West Country, Bridget heard that he was at the new Southwold house, which was near her own home in Suffolk, and invited him over. This was how David met Barbara, who had a small room for her own painting which she encouraged David to use. He had started to paint, still untaught, while he was convalescing. Barbara was already a student of Cedric Morris's at his East Anglian School of Art, and it was she who persuaded David to enrol there. The school was then at Dedham, before the fire which caused the school's removal to Benton End, Suffolk, with its famous garden created – and painted so often – by Cedric Morris.

There are stories of the fire which consumed the school at Dedham, of a Buddha that the students were drawing and upon whose hand Lucian Freud is supposed to have placed something disrespectful the day before the fire took place; and another story of David calling on the young Lucian one day in his room and finding him painting the skinned body of the school cat – which had died only a few days before – with the cat's pelt on his head as a kind of Davy Crockett hat – but it is hard to disentangle reality from apocrypha. David wrote stories about these antics, and other events in a famously eccentric school, which are now in the archives of the Carr family. Morris's portrait of David and Barbara, painted shortly after their marriage in 1942, is now in the Tate; and at David's eventual home, Starston Hall, two or three paintings by Freud were hung and remain still with the rest of David's very personal collection.

The reality and purpose of life for David now was painting. His early work is clearly affected by Cedric Morris's example: sharp contours, clearly delineated forms, a slightly naïf treatment of figures, quite thickly if smoothly painted surfaces, decorative rather than analytically simplified shapes and a narrowly restricted palette. His subjects were wholly figurative: landscape, still life, and figures, fellow students or himself.

15

David was a boarder at the school for three years; his holidays were spent either with Barbara at her family home in Suffolk or at Montrose House or at the family cottage, Sea View, near Rye on the Isle of Wight. He began to travel abroad for the first time, independently, in the holidays. The war started.

David made trips to London and served for a time at fire-fighting. Barbara worked as a nurse. In 1941, David applied to do his national service in the merchant navy and later, the ambulance service – his Quaker upbringing made it impossible for him to participate in fighting – but was turned down on medical grounds and so, instead, worked on the land, on a farm in the Mendip Hills, in Somerset, owned by a novelist friend, Eric Knight (*This Above All*). Barbara accompanied him to Somerset and, although they both worked hard, they were able to continue in a reduced form with their painting. In 1942, David painted some scenes of Bristol docks and the Rhondda Valley. In 1943, he bought his first painting by Lowry, and began a regular correspondence with him which led to a close, lifelong friendship. And in 1944, David bought Starston Hall: a substantial seventeenth-century farmhouse, in Norfolk, near Harleston but deep in gently undulating farmed and wooded country.

David's eldest son, Patrick, was born in 1943 and his earliest memory of Starston is of the great winter freeze of 1947 when the whole of England was under snow and a particularly dangerous black ice – a grim post-war winter made worse by prolonged strikes and power cuts. England was low after the war and there was still stringent rationing. Patrick remembers helping to shovel the snow away from the front drive at Starston and the memory is consistent with the general harshness of conditions at Starston Hall at that time, a remote house without any of the usual comforts, let alone amenities, until the late fifties. To begin with, for years there was no electricity or gas or telephone and even the water was pigmented with iron from a well dug many years earlier. The pipes had to be replaced every decade or so. With oil lamps and primitive heating, the winters until the late fifties, when David's financial position improved, were of a severity that today can hardly be comprehended. Patrick Carr has memories also of his mother's home, Pettistree Lodge, near Wickham Market, in Suffolk. Patrick and his father and mother spent many holidays there – and later with Patrick's younger brothers, John and Robert – with the pleasures and comforts of a solidly established house after the rigours of Starston at that time. Pettistree Lodge had a big walled garden with fruit trees and flowers which was seemingly filled with birds and butterflies; it is very much a childhood memory, but what is interesting is the lack of interest shown by David in nature. He went fishing sometimes with one or another of his sons, but really only came to terms gradually with the countryside in later years. In the early days, it was outside his field of interest and when he wasn't painting or doing chores he was off in the car to London for intellectual or visual stimulus. And David never went on holidays with Barbara and the children, although he sometimes went to the Isle of Wight for a brief sailing holiday with his younger brother Richard.

David's relationship with East Anglian society was the same as his relationship with nature – arm's length. But he made local friends, notably Alan Milburn, an authority on Spanish and Portuguese language and literature, who introduced David in the later fifties to modern Spanish painting, and Baron Ashe, an art collector who lived at Wingfield Castle in Suffolk and restored country houses. After David founded the Norfolk Contemporary Art Society in the early fifties, he knew Lettice Colman, who became chairman of the society, at Framlingham Chase. He got to know Mary Potter, the artist, at Aldeburgh and the Britten circle. He formed a close friendship with Tristram Hillier, the artist, in Suffolk. Quite separately, in London, through his friendship with Colquhoun and MacBryde – probably formed simply through his visits to the Lefevre Gallery – he met the poet George Barker and his wife, Elisabeth Smart, the poet and novelist – the nucleus of a Soho and London studio society of acquaintances which included Prunella Clough and Brian Reade, the Beardsley scholar, at the Victoria and Albert Museum. One of the reasons for the way in which David would suddenly appear in London, without warning, was the lack of a telephone at Starston through most of the fifties.

He began to keep serious hours as a painter at Starston in 1946-7. By 1947 and the big winter freeze he had established the attic room as his studio and put in a large north-facing skylight. When he was at Starston he worked every day. His mother, Marjorie Carr, had a house in London, in Yeoman's Row, and gave David a room there to use regularly on his two- or three-day trips to London, but he never worked there. He began to collect, modestly, beginning with Lowry, Clough, Hillier, Colquhoun, MacBryde, Vaughan and Appel, in addition to the Cedric Morris and Lucian Freud pictures, and then in the late fifties, the Spanish artists, Tàpies, Millares, and Saura, encouraged by Alan Milburn and by the distinguished dealer at Tooth's Gallery, Peter Cochran, who first showed the new Spanish art in London. He was not interested in the kitchen sink painters or the various Slade-influenced artists. And he was not interested in sculpture of any kind, or in antiques or *objets d'art*.

In London, in addition to the French or the Swiss pub, he drank occasionally at Muriel Belcher's Colony Room and he knew the Gargoyle and the Mandrake clubs. He joined the Establishment Club, amused by the satirical routines of Peter Cook and company, but he was purely a social drinker, going where his friends where, untouched by the excesses of Soho in its late phase at that time. I remember him with usually a half-pint of beer in his hand when we met in pubs. He really liked the rather grand and glamorous parties that he sometimes wandered through in London or the country. He went on short trips to Amsterdam, to visit museums and galleries, and to Paris – but these were serious excursions, to see something. He didn't travel much otherwise because, without languages, he couldn't talk to people and he felt frustrated.

I met David Carr for the first time early in 1948, in London, at the Lefevre Gallery in its New Bond Street phase. It was the year of Dubuffet's great North African watercolours, when Peter Brook's magnificent production of *Boris Godounov* appeared at Covent Garden with sets and costumes by Georges Wakhevitch and Paolo Silveri singing the great role, when Katherine Dunham's so-called Caribbean dancers arrived with such impact in London for the first time, Mae West was seen on stage in her own weird production of *Diamond Lil*, and Cocteau's film of *Orphée* was screened.

The occasion for meeting David was a 'between shows' mixed group at the Lefevre of small paintings by Keith Vaughan, boats and beaches, low-keyed, rather turgid and distantly Braque-influenced; one or two strong paintings by Robert Colquhoun and Robert MacBryde, Italian puppet figures by Colquhoun and still-life pictures by MacBryde; some vividly coloured ink-and-watercolour Mediterranean scenes by John Minton made about the same time as his Corsican travels with Alan Ross; two or three abstract gouaches by John Tunnard; a wooden carving with painted colour by Hepworth and two or three small, jaunty semi-abstract still-life paintings by Nicholson of St Ives motifs: a typical house show of the period. While I was living and studying in Paris for a year, in 1947, I had been invited by Duncan MacDonald, the lively and irascible director of the Lefevre, to start work in the gallery when I returned to London and I had accepted his offer. The Lefevre in 1948 was not only famous for nineteenth- and twentieth-century French painting, as it is still, but also represented through MacDonald's taste and enthusiasm some of the best artists working in England at that time. As well as Hepworth, Nicholson and Burra, with the two isolated figures of Lowry and Tunnard, the younger Lefevre artists, Colquhoun, MacBryde, Minton and Vaughan formed the major part of that English neo-romanticism which had come into being in the isolated, insular war years and included John Craxton and Michael Ayrton. The prevailing mood had been encouraged by Geoffrey Grigson's revelation of Samuel Palmer and affected also by the disparate examples of Sutherland, Lewis and the Picasso-derived style of Jankel Adler, the gifted *emigré* Polish artist, who had spent time in Scotland as a refugee and got to know the two Roberts, Colquhoun and MacBryde.

In 1945, at twenty, I had written an article for *The Studio* on these younger artists. MacDonald had been encouraging and helpful with documentation and photographs and his offer towards the end of my time in Paris in 1947 seemed to provide a good opportunity to work for a while in close proximity to the English artists that I admired most at the time. In 1948, I had been working at the Lefevre for only a few

weeks when David Carr, at thirty-two just ten years older than me, walked in to see the mixed show but more specifically to see some paintings by Lowry that had recently arrived from the artist's studio. Lowry was already popular as a painter among a wide range of collectors, notably H. E. Bates and some other well-known writers, but the prices were still modest. David looked at the Lowrys in the passage beside the storage racks, occasionally bringing a small painting into better light by a window in the gallery itself. I don't believe that he bought anything; he was intent on exploring these paintings to see how they compared with the one he had bought directly from Lowry earlier in the year. David had been among the very first admirers to buy work from Lowry and had evidently started up a lively friendship with the affable but notoriously reclusive painter.

MacDonald had warned me that although David was a great charmer, he was also an obsessive talker and that I should keep him to the point. He was quite accurate: David *was* an instant charmer, darkly good looking, like a young Olivier, casually dressed, and with an instantly conspiratorial manner of conveying irreverence and free-wheeling intimacy. After each of his wilder remarks, which were frequent, he would look swiftly over his shoulder to see if we were overheard, like a comic stage villain. His talk was an odd mixture of mature aesthetic judgement and half-serious and half-flippant opinions about the antics of the art world – with a schoolboy delight in the scurrilous gossip. I was amused by all this, shared many of David's enthusiasms in contemporary art – though not wholeheartedly for Lowry – and grew to enjoy his gallery visits. These were regular and fairly frequent. He came to London every ten days or so, with odd gaps, and meticulously covered all the London exhibitions. He sometimes timed his visits so that we had a beer and sandwich lunch nearby, when he could indulge at greater length his evident passion for art-political hypothesis or the more straightforward dissection and analysis of individual talent.

He became a cherished acquaintance rather than an intimate friend because we didn't meet anywhere else or discuss anything but art, leavened by personalities. David usually arrived at the gallery without warning, only occasionally sending a postcard beforehand. Close friendship was also ruled out by the repetitive way in which an opening exchange, in which my views were quickly sought, soon turned into a one-sided monologue. David was a bright talker but I soon realized that after finding out what I knew about art in post-war Paris he had cast me as a receptive sounding-board for his own flow of talk. I didn't mind: he was nearly always amusing to listen to and much better informed in his serious thinking about art than any of the other collectors that I talked to – and it was as a collector that I still saw David. Other, closer, friends of mine at the time, notably the painter and engraver Merlyn Evans, set a higher standard for me in intellectual discussion and ideas – David always seemed rather over-emphatic for his limited knowledge. In this year, 1948, we met only in the Lefevre or in pubs. I had little idea of David's country life in Norfolk, and was at first influenced by MacDonald's view of him which was amiable but kept

David firmly pegged to the role of a modest, if enthusiastic, potential collector – David bought a fine Bauchant from MacDonald as well as several paintings by Lowry, Colquhoun and Vaughan. MacDonald knew that he was also a painter but didn't want to take the idea too seriously because David was more useful to him as a collector – he already had all the younger artists that he could manage on the books of Lefevre. David didn't invite him to see any of his work.

And David didn't really look or behave like an artist: the invariable French blue, linen shirts, good tweed jackets with leather patches, and strong leather brogues, his educated voice and courteous but authoritative manner all combined together to support the presence of a cultivated, unusually dashing and up-to-date, rather eccentric young country squire. This was in fact quite deceptive: David used the country on his own terms and was left wing in his politics, campaigning for Attlee on soapboxes in nearby Harleston in 1945 – though in reality he was apolitical, too idealistic and intransigent for a political role.

In retrospect, I believe that at this time and perhaps throughout most of the following decade, the fifties, David was increasingly sure of his own ground and more and more confident of his own development as an artist. But he was still nervous of actual exposure, the ultimate commitment of having finally to exhibit work at the same level and in the same public arena as his own passionately admired heroes among contemporary artists. He did not wish to risk comparisons and a possibly demeaning drop in status. He enjoyed playing the part of a patron and an enthusiast, not at all condescendingly, *de haut en bas*, but certainly with the unconscious reassurance that art, although tremendously alive for him, full of electrifying elements to observe and discuss, and not without private drudgery, was also safely *over there* and not, more alarmingly, *here*, at David's own fingertips, and visible for all to see. He was also a perfectionist as an artist, with the highest standards, and this perfectionism also cautioned him to bide his time.

His self-confident, unfailingly assertive, button-holing manner was quite different, in extrovert *bravura*, from how he would have been alone, working on the kitchen table or in his studio at Starston. He kept his privacy as inviolate as he kept all his different friendships private and separated from each other – and from family life. David's double-edged public manner in London only related to the first two or three years of our acquaintance. Later, through the fifties, as this acquaintance deepened into a relaxed friendship, so David's attitude towards his own work changed to a more clearly focused approach whenever he mentioned his work or working preoccupations to me.

In 1949, I took a new job that presented itself in Cambridge as director of Heffer's Gallery. This was not as grand as it may sound: the gallery was on the top two floors of Heffer's stationary shop in Sidney Street, quite separate from the bookshop in Petty Cury. The gallery had top light, decent space and real possibilities which I seized with both hands but conditions were tough and heavily commercial. Somehow, my

assistant Jane MacIntire, later to become Jane Grigson, and I presented a strong series of shows – which made their mark in a university town where, until then, there had been no opportunity to see contemporary art – including the first show of modern French paintings, from Renoir and Gauguin to Picasso from the Kessler and Penrose collections, among other sources, and the first sculptures by Henry Moore to be seen in Cambridge. David was among the earliest visitors, teasing me about the office equipment and stationary on the floors below and full of enthusiasm for what I was trying to do, running a gallery for the first time.

He seemed to be in Cambridge fairly often, largely through the presence as an academic of his friend, Alan Milburn, the authority on Spanish and Portuguese literature and history from whom David received his first sense of modern Spanish painting. In the mid-fifties, a set of six coloured prints by Tàpies was bought by David and his friends Alan Milburn and Prunella Clough, each of the three friends keeping two prints. In Cambridge we continued to meet from time to time for pub lunches and go over London art gossip as well as more solid issues.

I worked in Cambridge from 1949 to 1952 before moving on to direct the Whitechapel Gallery, and David's outlook seemed to change during this time. He was slightly more concerned with subjects other than art: with the state of England, with social attitudes, changes and fixtures, and with English taste which he largely derided. He occasionally described factory buildings and industrial working processes, visually. Before, in London, we had only talked about art in a kind of vacuum, except for admiring references to Lowry's accurate rendering of the smoking Lancashire towns, villages, urban parks and beach scenes, or the heavily atmospheric, abstractly composed landscape paintings of Frances Hodgkins – another artist in the Lefevre stocks – of Corfe Castle, in Dorset, where she lived in her later years and which David had visited during the war. David was not really concerned with landscape but he admired Frances Hodgkins, and Paul Nash. There was suddenly far more talk about art and industry, functional design and the dreariness of the average English domestic interior. There was still talk of parochial matters like the politics of the Royal Academy, the affectionately observed foibles of its secretary, Humphrey Brooke, who was an old acquaintance and Suffolk neighbour of David's, and other hobby-horses. It was the time of Munnings and his attacks on Picasso.

There was also talk of the Dutch Cobra painters, whose work he had seen on a trip to Amsterdam, and notably Karel Appel, whose work he collected and with whom he corresponded and had already established a lifelong friendship. David also admired the paintings and engravings of Merlyn Evans whose work I presented in Cambridge in a one-man show in 1949 or 50. He was impressed by the strong drawing and abstract invention in Evans' work and especially by the mechanomorphic imagery, so close to his own pursuit, in Evans' semi-abstract industrial landscapes, in which warehouse structures reared up with the same baleful impact as prehistoric monsters. The compacted form, not dissimilar to the tightly packed shapes

in David's work, came in Evans' case from a love for the carvings and totems of British Columbia, with their burnished surfaces and rich-hued, darkly glowing colour. The irony in some of Evans' work also appealed to David, and his artistic identity as a whole was a discovery – Evans had been away through the war in the Italian and North African campaigns and in the thirties had shown with abstract groups as well as the Surrealists.

The more serious subjects that David talked about and the emphasis on the industrial scene as subject matter, going back often to Lowry's grim portraits of mill workers or coal miners and the way in which his paintings had opened up the industrial scene, expanded our conversation, as opposed to the earlier talk about art in a kind of vacuum, which only expressed David's sense of being a special sort of working connoisseur, assessing the achievements of others. He had not really discussed his subjects or his approach to painting before, only his liking for those he considered kindred spirits – Robert Colquhoun for one, whose work he had bought, Lucian Freud, Tristram Hillier, then Appel and most particularly Prunella Clough whom he met in 1949, and with whom he had his closest friendship. I still had not seen any of David's own paintings; their identity resisted conjecture beyond the fact that he was clearly concerned with images and found totally abstract art unsatisfactory if sometimes admirable. Gradually, from 1950 on, he spoke of his new theme, the factory and men and machines.

In 1948, Humphrey Jennings, the film director, and I struck up a brief friendship (he was killed filming in Greece only a few years later) and Humphrey showed me, in that same year, a large number of his paintings of industrial and agricultural equipment, part of his immense, complex study of our industrial revolution which was published posthumously – as recently as 1985 – as an anthology: *Pandemonium*. It would be tempting to think that David's passion for the man-and-machine motif came from a general awareness of Jennings' pursuit compounded with pre-war years of Mass Observation surveys in factories, *Picture Post* photography in which Bill Brandt and others revealed England to the English, and the new awareness of factories and industry brought about by the way in which so many had spent their war years in industry. This awareness was partly responsible for the appearance of post-war sculpture in England, welded, forged and rivetted constructions by Butler and Chadwick, for example, using industrial processes that were then quite new to sculpture – Gonzales was not generally known here until later. But the truth is, I believe, that David was too obsessive a type consciously to absorb things of this kind: he had worked on the land, in deep country, during the war years, and, except for art school in the country, this was all that he had known apart from galleries, museums and a few studios. But he had become aware of the family biscuit business as a possible source of imagery and his paintings of men and machines came directly from visits to the factory in 1949 and 1950. Prunella Clough, who had similar interests at that time in urban detritus and wastelands as well as factories, remembers

with amusement that David was quite irritated when she spoke to him of Wright of Derby or any other artists who had tackled the theme of men at work; he preferred to believe that his own interest was without precedent.

There was, also, of course, the Festival of Britain of 1951 looming up as a veritable celebration of David's themes, and certainly enshrining industry as well as art and design and style as a whole. The festival was much artier than the simple locations that had begun to absorb David, and included also science and architecture, but he would have been as aware of this national event as anyone else. David's interest in the factory as a subject may have been warmed or encouraged by the factory recruitments of the war years, *Picture Post*, Mass Observation – no intellectual in England was unaware of this pioneer work – and the Festival of Britain, but I still believe that he was following a personal obsession of his own, quite apart from the *zeitgeist*, and that the family business was the determining factor, so readily to hand as a subject, and stimulated by the early friendship with Lowry – whose approach to the industrial scene was coincidentally, in sharp contrast to David's own vision, quite conventionally picturesque, and by his fast-growing friendship with Prunella Clough. They acted as an intellectual and professional stimulus for each other and they had both come from the same assured social background and had had to find their own way out of it.

My memory of David's wider conversation in the 1949-50 period, and his references for the first time to his own work and subject matter, is quite clear. We knew each other a little better and had established a more relaxed basis for David's confidences about work and views. Cambridge was a more informal place for meeting; and our encounters, usually unplanned, were still, as in London, quite erratic, never more than once a month and with many gaps between. We never dined together or went on a jaunt of any sort, only met and talked in galleries or over a pub lunch. But in the fifties David projected far more positively the sense of being an artist and not just an amusingly opinionated collector. His son, Patrick, has confirmed my early impression that although David may sometimes have come across rather self-indulgently, he was emphatically not a dilettante – he was far too obsessive a type to do anything any other way but thoroughly, up to the hilt. He was first and foremost a painter, sometimes playing other roles in specific contexts, but this role-playing fell away from him gradually through the fifties. With hindsight, I know that 1949, when he first visited the family factory as an artist, deliberately to make drawings, was a turning point in David's life.

I visited Starston in the late fifties. I had left Cambridge to direct the Whitechapel Gallery in London in 1952 and, still seeing David as a regular visitor to the Whitechapel shows, had accepted an invitation to visit for a weekend the cheerful and delightful country home of Lettice Colman at Framlingham Chase near Norwich. Lettice's large house was very often at the disposal of the Norfolk Contemporary Art Society and was where, as chairman, she organized art panels and very enjoyable

dinner parties with artists and other London visitors mixed up with unfazeable country neighbours who looked upon some of Lettice's modern art jamborees with the same calm attention they would bring to bear upon an agricultural or cattle show. Norman and Jean Reid spent weekends regularly in a small gatehouse on the estate as a refuge from the Tate Gallery. Although Lettice presided over the Norfolk C.A.S. the whole scheme had been invented by David, following the precept of the then Tate Gallery-based Contemporary Art Society. Lettice was a generous hostess and I often visited her at Framlingham Chase with my great friend Christabel Aberconway and other artists. My trip to Norfolk on this occasion was also to pay a visit to Starston to see David's paintings, at last. I believe the time would have been the summer of 1958 or 1959. David had spoken of Starston, even in the Lefevre days, but usually with a rather wry affection as a place of hard work. He may have waited until 'the amenities' were installed before inviting an effete Londoner like myself, but he and Barbara had never in fact been particularly hospitable to outsiders: their home and family life were private.

David appeared at Framlingham for dinner, warmly welcomed by Lettice – they both worked hard for the Norfolk Contemporary Art Society. David skulked around like a banked fire for the evening, on his faintly alarming best behaviour. Francis Hawcroft and myself were taking part in a discussion panel with Alan Davie, among others, and Francis and I were both invited over to Starston the following day. At that time, Francis was Curator of Painting at the Norwich Art Gallery and lived in Norwich, before he moved to the Whitworth Art Gallery in Manchester.

Starston was a revelation. As the director of a public gallery forever in quest of works of art for exhibitions, I had been a weekend guest in many of the great country homes in England, but I had never seen a country home before that had been kept in such perfect and wholly unpretentious eighteenth- or early nineteenth-century country house style. It was high summer; the deceptively small-seeming, rectangular house, so roomy inside, completely engulfed by deep green and gold country, ploughed fields and crops, grasslands full of flowers, woods and copses, a rolling landscape right up to the plain front door, without even the flattery of a flight of steps or grand portico, was part of the landscape. A stone-flagged hall, drawing room to the left, dining room to the right, bare wooden floors, a few rugs, fine period furniture – and flowers everywhere, on tables, on shelves, on window ledges, mixed garden flowers, beautifully flung together and wild flowers. Many tables in the two main rooms were covered with small precious objects: pictures, photos, enamel boxes, stones, jewels, mementoes, toys, clocks, musical boxes. Starston was Barbara's special creation, it was plain to see. A countrywoman from birth, and not, as in David's case, by adoption, she adored children, dogs, horses and her painting but had little interest in conventional domestic pursuits, or in cooking. David had always done all the cooking, which he enjoyed, and he looked after the hard side of things, digging, sawing, or repairing the house. The taste everywhere, which was the finest and most delicate

imaginable – and very much an artist's fine taste – was wholly Barbara's and managed to incorporate the paintings by Freud, Lowry, Colquhoun, Bauchant, Clough, Vaughan, Hillier, Bonnard (a lithograph), Jack Smith, Morris, Millares, Saura, Tàpies and Appel – and a small portrait of Cedric Morris by Freud that he gave to Barbara as a student. The paintings were placed on the walls in an almost casual way, the house was an untidy, unglossy family home, but the elegance and unself-conscious prettiness were unforgettable. The feeling of being outside the time-flux was very strong, also, as if the hall and the two main rooms were a foil for characters drawn by Dicky Doyle – one expected to see chairs round the wall, ready for a dance, as in a novel by Thackeray or Dickens. The atmosphere was entirely unself-conscious and accentuated, I suppose, by the lamps placed in each room and by Barbara's extraordinary *mélange* of tiny games, toys and *bibelots* of all kinds placed around the rooms, precious, delicate, full of colour and light.

I have no clear memory of David's studio: a recent visit brought back its loft-like character at the top of the house. The work seemed worthy, serious, sharing common ground it seemed with Prunella Clough – and very much with Colquhoun in some of its formal solutions – but with its own presence. I wasn't shown more than a small number of paintings, no sketchbooks or studies, and only the man-and-machine paintings. If any of the earlier Lowestoft or Irish paintings were visible at all they must have been only coincidentally hung with other paintings, in one or two places in the house – and only one or two at most, in little-frequented places: a back hall, or David's bedroom. In his studio, they would have been stacked away as 'old work', but I seem to remember one or two hanging in the house.

On this visit, I realized most vividly how deeply personal to David were the separate but interrelated strands in his life: painting, collecting, and his work for the Norfolk Contemporary Art Society – where he had occasional quarrels and feuds. He was a maverick, fundamentally an auto-didactic one-man band, and no respecter of authority if it imposed in any way on his own ideas, opinions or activities.

From about 1949 until the end of the fifties, David sustained his theme of man-and-machine, a long and powerful sequence of oil paintings. At the same time, he created an equally strong series of small-scale, quite intimate, watercolour, coloured ink and pencil drawings in a progression of immaculately ordered images. Each sheet contains related sequences of ideas, usually referring to the man-and-machine idea but sometimes exploring the theme of machines in isolation, seen as increasingly fantastic abstract constructions. There are usually two, three or even four drawings to the page in sequences which also explore a specific range of colour. Some drawings refer to larger oil paintings, although in no sense are they 'preparatory' drawings but complete in themselves. They are all strong and highly concentrated.

These drawings more than match the inventiveness of the oil paintings. In the man-and-machine images David sought to make an imaginative fusion or formal synthesis between the human form and the machine in a series of complex structures

which become clearer and grander and more spacious as the series progresses. The larger, vertical canvases of 1957 and 1958 have an ease and poise about them which is different from the 1950-55 canvases, where the design is far more compacted, dense and almost claustrophobic. The range of colour is always simple but rich: indian red, orange, blue, black, grey and ochre and variations on these colours. The watercolour drawings invoke a brighter pitched and higher range of colour.

David's earlier paintings, completed at Starston, are very different in their domestic themes or portraits of grim-faced, black-shawled Irish peasants or Lowestoft fishermen and net scenes, but their extreme simplification, compression and use of strong contours make a loose connection with the man-and-machine images which followed them. These early paintings show the influences of Cedric Morris in the simplification of form, dense use of creamily opaque pigment and obsessive focus on edgy still-life sequences; Lowry in the whites of sea and sky, black horizon lines and cold blues, reds and grey-green; and Freud, marginally, in the big, staring, close-ups of heads and graphic delineation of features. The early works have an intense charge of their own, in which domesticity has a loaded stillness and the peasants or fishing folk have the tough simplicity in structure of pub signs or primitive art.

In the factory paintings, there is no interest in a decorative treatment of the figure and the machine, more spaciously set out and balanced as in Léger's compositions. There is the feeling of the creation of a new hybrid, in which man and machine are so synthesized as to make a new, complex whole, and this is first plainly set out, in its purest form, in the 1950 *Dough Maker* painting. The play with structural and formal tension throughout the rest of the sequence is highly inventive, and gains in intensity and distillation as the sequence progresses.

It is useful to recall the context in which these paintings were made, apart from David's private domestic life and activity as a collector or explorer of art. In the late forties and early fifties, the only foreign artists with any fresh impact in London were the French artists Pignon, Manessier, Bazaine and Tal Coat, whose abstract work was in opposition to the more realist paintings of Gruber and Reyberolle – which shared common ground with Guttuso's neo-realism in Italy. Poliakoff, de Staël and Soulages were solitary figures, wholly separated from any groups or movements, and so were Wols and Bissière. Dubuffet supported *l'art brut* as a movement but was really a huge individual figure. The hard-edge abstractions of Dewasne and Herbin did not penetrate English awareness at that time. Tàpies was beginning to be known here in the early fifties, to be followed by Saura and Millares. Karel Appel and the Cobra artists in Amsterdam were also known in England by the early fifties.

Which artists did David know personally and meet on a friendly basis? Obviously, his early mentor Cedric Morris, and his fellow student, Lucian Freud. There was his friendship with L. S. Lowry and, after a visit to Amsterdam in the early fifties, with Appel. He knew Prunella Clough also, and probably saw more of her, and more regularly, than any other artist, and Colquhoun and MacBryde. He also knew

Tristram Hillier, Mary Potter, Dennis Wirth-Miller and other Suffolk-based artists.

David's allegiances were to European painting: he enjoyed a lot of the American art of the sixties, notably, Rothko and the Abstract Expressionist painters like Pollock and Kline, but he was not put off his stroke by American art. David's mature personal vision had been given the signal for release, as it were, by the example of Léger, and, very differently, in approach, by Kandinsky and Miró. What he did finally was very much his own.

In 1960, David was told that he had cancer of the lymph glands. Hodgkin's Disease was not fully understood at that time and treatment was less effective than it is perhaps now, but David faced up to the blow with great courage. He changed the modest country car for a Porsche and enjoyed, as much as he was able to, the expansion of art and life in the sixties. He began to work in a long series of foolscap-size watercolour sketchbooks, using ink, crayon, pencil and wash as well as watercolour, and to create an extraordinary range of new images reflecting a new and eclectic range of interests. The subjects moved with great freshness through Faces, Heads, Organic Forms, Musical Notation, Machinery, Medical, People and Allegorical – these are the titles of some of the books. He treated the subjects as a series of progressive theme studies, often drawn or painted from life as in plant studies, and bound the work in hardback books, each containing about thirty pictures. Altogether, nearly eighty books were completed. Patrick remembers his father working at these images through the sixties, sitting in the evenings at the kitchen table and painting and drawing in the books, usually with music, Bartòk, Janacēk, Verdi or other operatic music playing at the same time.

David's work through the forties and fifties shows tenacity and individual invention. But the later watercolours, a mixture of imagined and perceived images, have a flow of pictorial invention and visual ideas that is a consummate achievement in range, variety and telling detail. There is, too, the fact that the earlier oil paintings, although admirable and suitably tough in their surfaces, have a somewhat inert or matter-of-fact evenness in their opacity. The watercolours have a far more vibrant and sensuous surface which David either did not want or could not achieve in the oil painting. I believe that the 'theme' books, made in the sixties, are of special historical importance in British art of this period.

In the spring of 1967, David visited New York for the first time, and returned to complete arrangements for an exhibition, early in 1968. The sculptures which stem from this visit are tall, soaring vertical shapes in fabricated acrylic and carved marble, sometimes designed to hang from the ceiling, and stem from his formal interest in the spaces between the sky-scrapers in the canyons of Manhattan. With these sculptures, David also completed in 1967 a group of black Pentel linear abstract drawings on hand-made, soft, absorbent Japanese paper which also refer to the forms and spaces of New York City. The sculptures should be considered as a supplement to and an extension of the large body of drawings.

There is something heroic in this last achievement, when David was gravely ill. He died in 1968, after completing everything for the exhibition, and the work was exhibited at the Bertha Schaeffer Gallery in New York the following year. Patrick Carr travelled to New York for the occasion. The same speculative formal energy and sense of perfection energizes these last works, which seem also to extend, in simplified and quite daring terms, earlier preoccupations – but translated into terms of an exterior environment. The scene had shifted to the urban outdoors, to the grand exterior contours and inter-related spaces of the cathedral-like buildings of Manhattan which house that half-human, half-mechanistic dynamo of energy. It was a perfect culmination of David's life's work, but he would of course have moved on to create much more if he had lived. He was spent physically, but not imaginatively.

Prunella Clough was closer to David Carr than anyone outside his immediate family and sustained through twenty years an affectionate friendship fortified by shared professional concerns and perhaps also a faintly sardonic humour or sense of the absurd. They met all the time and travelled together to see things – sometimes joined by a mutual friend, Brian Reade, the Beardsley authority from the Victoria and Albert Museum. They also kept up a lively correspondence, detailed and intense from David, mainly dealing with work, and brief and brisk from Prunella who has kept a few copies of poems about war and landscape dedicated in 1939 to David from Sidney Smith, his fellow undergraduate who travelled to Italy with him, and some correspondence with the Bertha Schaeffer Gallery in New York, and Rudolph Arnheim, the authority on visual perception, arising out of the posthumous show in New York of David's sculptures and drawings – Prunella helped Patrick Carr to deal with the arrangements of the show, after David's death.

They met in either 1948 or 1949. Prunella Clough stayed fairly regularly with old friends of her mother's at Southwold with whom she had spent occasional holidays since childhood, and David and Barbara had seen a semi-abstract painting, close in spirit to David's concerns, that she had exhibited in a modest local exhibition. David tracked her down in London through mutual friends, Robert Colquhoun and Robert MacBryde, and appeared, unheralded, at her Beaufort Street studio – 'he was a gambler,' says Clough, talking about the way in which David moved around. She was about thirty, David was about thirty-seven. They formed an instant friendship, David presenting himself as a painter from the beginning and dressed as always in a blue work shirt, bought from a chandlers and outfitters in Lowestoft – 'it was our Marks and Spencers'.

Clough confirms David's auto-didactic and obsessive nature – 'he liked to follow trails' – and recalls a visit they paid together to Lowry in the late fifties, motoring in

David's car to the Lancashire village of Mottram-in-Langendale, near Manchester. Lowry's house was stark and solitary, on a bleak hill like a Lowry painting, and Lowry's studio was 'the front room', full of pictures and with white paint spilled and spattered everywhere in an otherwise dark interior. The house was filled with ticking clocks, reverberating in every room and passage. David was at ease, after many visits, but still addressed the painter as 'Mr Lowry'. Prunella admired a small picture and asked if she might buy it. Lowry told her that the whites weren't right yet, he 'painted for the future', but he allowed her to have the painting. Lowry out-talked David, gossiping about people locally and the London art world, rather as a local hick. After the visit, David and Prunella explored Oldham, 'at that time a factory district of Manchester and alive, how very different'. They walked a lot and looked. Prunella had been interested for some time in mining areas and they explored these, as well. David 'shared [her] interest in the backyards of factories'.

When he began to make small sculptures for a year in the late fifties, 'he haunted machine shops and agricultural repair shops for spare parts – Ransome's in Ipswich were great agricultural machine manufacturers in those days. David didn't buy machine parts but walked about, drawing.'

Prunella usually visited art exhibitions with David – 'he worked at art seriously and silently' – but she remembers occasional pub jaunts in Soho, to the French pub or the Wheatsheaf. He was critical of the Ayrton-Minton aspect of painting at that time and saw it as nearer to books or the stage. 'He took to writing but secretively, without discussion, and read little. Other people's experiences didn't interest him, he felt he had to experience life as if it had never been experienced before.' But 'when he began to read Robert Musil in the sixties he was completely taken over by him and he had always had addictions for particular writers, notably for Sterne in the fifties.'

'He didn't bother to keep up with his contemporaries – he was an obsessive, a tough thing to live by. He had no way of switching off, or basking or cruising. Whether he was painting a room or doing a garden, he had to make it a perfect job. His contact with the art world was patchy and limited, or local. He didn't know the Cornish painters, for instance – he wasn't part of "a village", culturally speaking, although there were nearby Aldeburgh and Norwich C.A.S. connections. Everything was separate: David was the fulcrum of an independant world.'

Prunella Clough and David exhibited at least twice in the same exhibition. In 1953, in my second year at Whitechapel, I included a painting by David in a survey of contemporary British painting at the Whitechapel Gallery in which Prunella also showed her work. And later in the fifties, a travelling show was organized at the Southampton City Art Gallery of paintings by David and Prunella as well as the two Roberts, Colquhoun and MacBryde, 'which fell like a stone in the regions'.

She remembers his discovery of acrylic in the early sixties and how he deployed it 'in a batch of work before all the watercolours and made in 1962 – in black and white

paintings painted on loose, coarse-woven, rough-textured jutes. These paintings are of organic images. At the end of his life he used black and white acrylic again in some smaller paintings related to the sculptures made at this time which express David's reaction to the Manhattan skyscrapers, experienced on his first visit in 1967, expressed as the spaces between the skyscrapers as solid shapes. Some of them are meant to hang from the ceiling, so that they diminish in scale as they descend because the solids, the real skyscrapers, do the reverse; the others ascend from their base in the usual way, expanding as they rise.'

Prunella Clough respects David's work with the man-and-machine motif and finds the earlier Lowestoft or Irish paintings still extraordinary. For her, though, the supreme achievement is in the watercolours. Two letters from David to Prunella, written in the fifties, and a note from the sixties are reprinted here because they touch so directly on central issues:

Starston Tuesday 6.45

Dear Prunella,

What is it that appears the same in all factory interiors and machine workshops, what *is* the essence of it all? You see I have been trying to work and as usual come right up against the unsolved problem. What one sees has absolutely no significance in the way a nude or a plate of cheese has significance, and yet any machine means a great deal more than an idle abstract shape. I have been thinking as much of your paintings as the places I've visited, and trying to follow your thinking on the matter. I am certain that your way is right for you, that any weakness is one of over-observation and a reluctance to leave out what you have observed. Then turning to my own work there is the reverse weakness of an inclination to leave too much out, to try and show the skeleton and not too much flesh. The abstract painters have done great disservice to art, teaching the eye to accept the easy solution and producing an aesthetic pleasure out of nothing, with the result that when a painter wants to get back to his own reality and finds that the visual world is not made up of simple shapes he is hopelessly confused as to what to make from what he knows to be there. An accurate report of the facts is no good, an over-condensation is worse: a man does not look like a machine but unless the mind makes him look like one the juxtaposition is even more improbable on canvas than in life. Painters have always managed to make the figures look like their own landscape invention so at least there is a respectable antecedent for the distortion. What is distortion? The real trouble is that factories in their nature do not break themselves into logical and understood units like a landscape which can be broken down to the weeds and stones by the foot as the eye looks across it. A domestic interior has its own logic that can be seen at a

glance. None of this can be seen in a factory and can be only understood in the mind's eye. So the painter is left to invent his own symbols for what he knows is there, and can only hint that it is worth investigating. There has never been subject matter of this type for observation, all the early machinery was made literally by hand; it was all beautifully obvious to see being made, now a 'simple' packing and wrapping mechanism is infinitely more complicated than a Tompian clock.

As usual 'special pleading'. But it shows things are moving.

David

. . . I really must keep copies of my letters to you because I forget what I write and when faced with complaints about 'cushioning' cannot remember what it refers to. Who's cushioning who? But I still see you don't UNDERSTAND. Quote: 'What I said was that the particular attitude to it wasn't new, the human-cog-in-a-stupid-process attitude which is at least as old as Wm Morris.'

I have never (repeat *never* to the nth time) hinted at a *stupid* process. The most I have said, which is also the least that can be said, is that: there is a 'process' in which a man and a machine are *interlocked*. The word stupid would at once unlock them, separate the man from the machine. I cannot yet pass judgement on the evidence so far accumulated. In totalitarian art judgement is passed: the worker is the healthy honest toiler working his machine for the benefit of mankind: in American mechanical art the same ideal is suggested. A man is always a man and a machine always a machine in such politically inspired art and if one does not share the same political philosophy as the artist the idea he shows to us seems false. (I'm waking up!) Why? Why? Why? I don't know and yet there must be an answer: though don't wriggle out by saying the pictures aren't works of art anyway: The healthy man and the super machine put together look false in painting and yet there are healthy men working super machines all over the world. Nor is man the slave of the machine; he likes the work which he chooses himself; he likes communal factory life; the more skilled he is the more he likes it and the more efficient he becomes at it. And yet when I'm in a factory enjoying what is there to see I am always aware of 'doubts' in the mind. i.e. I see the worker is happy making what he is making, but is what he is making going to make him happy? If the answer is an unqualified yes than in future all my faces will wear a complacent smile. The answer of course is a new classical conception of the machine worker: a face and figure that does not interfere with the conception. In Greek sculpture of athletes one is not disturbed by the physiognomy but only aware of the dignity of man and the activity of sport. The Discus Thrower is at one with his disc which he is about to hurl for the joy of hurling and, mysteriously, we know that he is the best thrower that ever was. It is all so simple, beautiful, and satisfying. His occupation is divorced from politics and economics in the sculpture . . .

31

I begin to see that there is no virtue in work; just another vice. Writing is spoiling the pleasure in reading, as painting spoils the more obvious pleasure in pictures. The eye is always on the lookout for the technical structure, the way the problems are solved. Exciting, yes, but just more work. Already, too, I find myself listening to conversation, treating it as so much food, watching the human body move and the expression in eyes; trying to see what everything means. The world will become one enormous machine workshop to me. I wonder whether it will ever crystallize out into anything worthwhile?

c. 1962

Bryan Robertson

I am grateful to Patrick Carr for his generous assistance in providing biographical material for this essay and my most grateful thanks are due also to Mrs Barbara Carr, Prunella Clough, Margaret and Brian Reade and Peter Cochran for their generous help with additional information.

B.R.

SOME LETTERS TO DAVID CARR FROM ROBERT MACBRYDE, ROBERT COLQUHOUN, BRYAN ROBERTSON AND L. S. LOWRY

Postmark Paddington 25th March 1944

Dear David

I beg you not to take too seriously my apparent depressed condition, the new months will do much to dispel that and lately there has been much help in what I regard as my fight with the 'art gangsters'. I need to think much about painting and liking even the business of painting. I miss it, but as I said to you I will not make anything just because I have a slight conscience about practice makes perfection. Not necessarily or the world would be full of geniuses. In any case reason spells death to such thinking. (Remember the big tradition of logic in the island lay in Scotland.)

It is so kind of yourself and Barbara to make an offer of a short holiday with you. These things are good but not all, it will work itself out in my mind and in my environment. One Spring weekend we'd like to come and see your new work. You certainly have got the first essentials of a painter – *passion*, but never neglect the means of expressing it otherwise you might as well sit and think.

It is always a great pleasure to see you in London.

Much love to Barbara and the children and yourself.

Robert Mac

Westgate House, High Street

My dear David

Robbie will be writing but I myself was so thrilled that you liked that painting, Peploe told us, because I thought it was so good. R after painting it thought nothing of it. You know how that blindness comes after work. The drawing in it with such simple colour was so genuine. I agree about the Minton Show but really there's so much of this kind of stuff that passes for drawing or for painting. That you liked the queenly lady of Robert's and recognized its genuineness convinces me of your critical ability, a good rare thing nowadays. We work for our joint exh. in May then I hope to Franco-Spanish border to take the sun and look at new objects and colours.

Our love to all and my thanks for backing up what I felt about that painting.

Love R Mac

Tilty 17th December

My dear David

This is to thank you very much for the picture, there is nothing nicer to have. I've been looking at it and I honestly am excited by your advance in painting – you ought to put all the energy you can muster into your painting and not too much into literary efforts. Beware of certain pitfalls in that direction and perhaps confine your literary efforts to good letters. Sometime I must ask Reid and Peploe why you cannot have an exhibition and if not them, I'll speak to Rex Mankwell and tell him what he is missing. Your figures need to be drawn stronger and we suggest that you actually disciplinc yourself in straight drawings of anything – you will be astonished how much better you will draw in colour afterwards. There is a tendancy for the picture to run outside its four sides but that you will undoubtedly defeat in time. Honestly. I am thrilled at your advance and beg you to keep hard at it, your excitement comes out of the canvas already. Please, by the way, forgive us for our behaviour. We don't always break out like you have had twice at Tilty the misfortune to witness and you must credit us with understanding why we express such violence. Actually, there is nothing to be afraid of in these circumstances and we know the cure of course. It is hard to be perfect in the circumstances we have had to deal with. I don't want to go into the details though I am sure you can guess some. While one should put every effort into breaking this emotion yet it is also part of the human tragedy. The Celtic soul *is* different and there is a tremendous desire to please which sometimes is misunderstood and not properly reciprocated. Anyway forgive us since it wasted your whiskey somewhat and you were kind over that. I must say you have been sweet to us all here so often you are amongst our few best friends.

Again thanks for the picture and a Happy Xmas to yourself, Barbara and the bairns.

Much Love

R Mac

May 16th '54

Dear David

I have been re-reading your letter to me of Good Friday in which you offer £20 for a

special picture for Salford.

Of course, I agree to do this and would like to make it a good one, especially since it would go to a public gallery. By the time you would be going to Manchester as you say in August I would have some to show you, then you could choose the one you want.

Now you know I mean this and would definitely have them, would you agree to give me the £20 now? I really need it urgently and it should make no real difference as to when it is paid and would help me considerably.

By the way, Bryan Robertson has asked us both to have a big retrospective show next year at the Whitechapel Gallery, with some big new paintings. It's a good idea and we'll decide about it when we see him and the gallery. So that's something again definitely to work for. I must find out if they can sell there or whether they can arrange for sales maybe after the show.

Please write and give me your news and if you agree to the above proposal (and please do) could you send off the cheque soon and help me.

Yours with love

Robert Colquhoun

Be sure David, I appreciate all the trouble you are taking over the Salford.

Tilty Wednesday 18th Aug. 1954

Dear David

Since Robert and myself will be sending a picture to Whitechapel perhaps you might have room to take them when you are taking your own. It is so difficult from here somehow. They are not very large. Anyway let us know soon if you are taking yours yourself. Glad that you are trying a large one. I agree that a big one is better and hope you can do it, and it must be attempted at some point of working, so long as it is not for art Politics instead of for Art itself.

Good luck,

love Robert

27 October 1954

Whitechapel Art Gallery
High Street
London E1

Dear David Carr

As you probably know, the present exhibition in which your picture is hanging together with the pictures by Colquhoun and MacBryde, will close at the end of this week, on Sunday. We shall be dispersing all the works next week, and I am wondering if there is any possibility of your coming to London with your car to collect your picture together with the Colquhoun and MacBryde. If this is difficult for you please do not worry about it, as we can make arrangements for transport. But, if you are coming to London in the near future and can manage three pictures this would help us very much.

Your own painting has been admired by a great many people.

With good wishes,

Yours sincerely

Bryan Robertson

The Elms
Stalybridge Road
Mottram-in-Longendale
Cheshire

6th November 1952

Dear Mr Carr

Well, the work arrived safely, I found it at home on getting back after a few days away.

Very many thanks for it – it already has acted as a tonic to me. I am getting it framed, and if you ever want it for a show I will send it with the greatest pleasure. For one thing alone, it is a lovely colour scheme.

Yesterday I had a friend and his wife here, who were passing through Manchester, who, foolish people, thought they knew everything about pictures. It completely shook them. They had never seen anything like it. They were holding forth about art, so I just thought I would give them something to think about, and their reaction to it was beyond my wildest hopes.

It is a fine work and grows on me.

Yours

L. S. Lowry

SOME PHOTOGRAPHS AND DOCUMENTS RELATING TO DAVID CARR

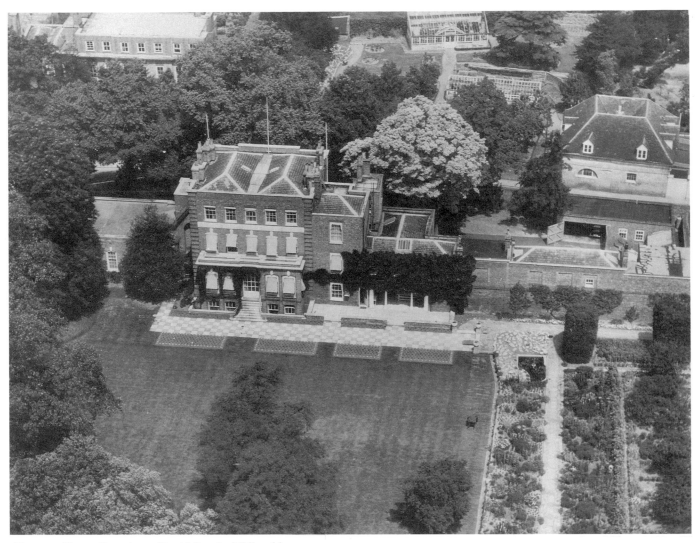

Montrose House, Petersham. David Carr's childhood home

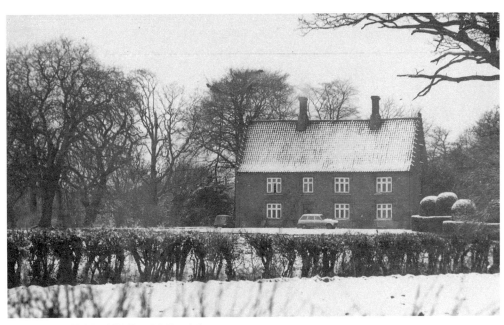

*Starston Hall, Norfolk. David Carr's home
from 1944 until his death*

David Carr as a young boy

David Carr at nineteen

David Carr painting at Benton End

*David Carr at Cousins Hill with his family
and his mother (centre background)*

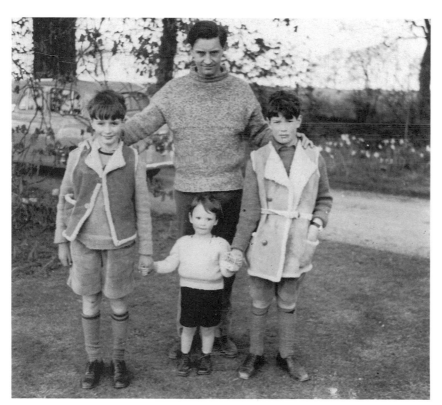

*David Carr at Starston with his three sons,
Patrick, Robert and John (1955)*

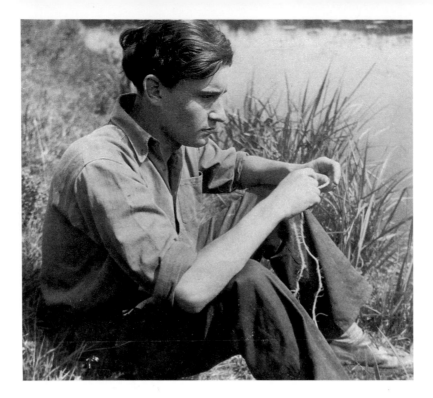

David Carr aged twenty-two at Pettistree Lodge,
his wife's childhood home

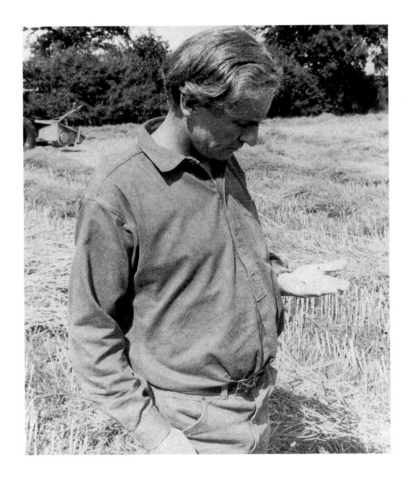

David Carr in 1967, a year before his death

Exeter College
Oxford.

23.5.37

My darling Tum.

I don't believe this letter will come as a very great surprise to you as you must have observed my feelings during the days I was at home last holidays. — After eight nerve wracking weeks I have made the irrevocable decision to paint. To give up everything I have been used to, my comforts, my car, my easy life and with £250 a year which I have asked from Father to go over to Paris and to study art. I know I can make a success. I feel so sure of myself (the first time in my life). Ever since

The letter to his mother, in which he tells her of his 'irrevocable decision to paint'.

I made that first stupid self portrait
I realized what I had been born to do. —
The type of life that an artist's lives is
my ideal, I adore a precarious existence.
I shall have to suffer a great deal, but I
feel sure that it will be far outweighed
by the tremendous happiness that I shall
often experience. — Darling I'm most
awfully sorry I've had to do this, I can't
help myself. There's something in me that
for eight weeks has been urging me on so
much that now I can't think of anything
else. — Of all the family I think you
will be the only one who will be able to
understand me. The moment you learnt

about Christian Science you must have
realized that you would always study
it. — I am the same; the moment I
learnt that there was such a thing as art
I knew that I would have to belong to
it, for it has the same force as religion.
You might ask me why I can't study it at
oxford, in the vacation, in my spare time
The answer is obvious. No amateur ever
succeeded in doing anything great. And I
have _got_ to do something big. I want to
make a name for myself. I have a horror
of sinking into oblivion. —

 I fear I have a very slight command
of the English language and therefore can't
write a convincing letter. Do come up.

and see me as soon as you like and
I can tell you much more –

All my love

David.

Humphrey Brooke writes in The Times *obituary column, 9 December 1968*

BLACK AND WHITE STUDIES

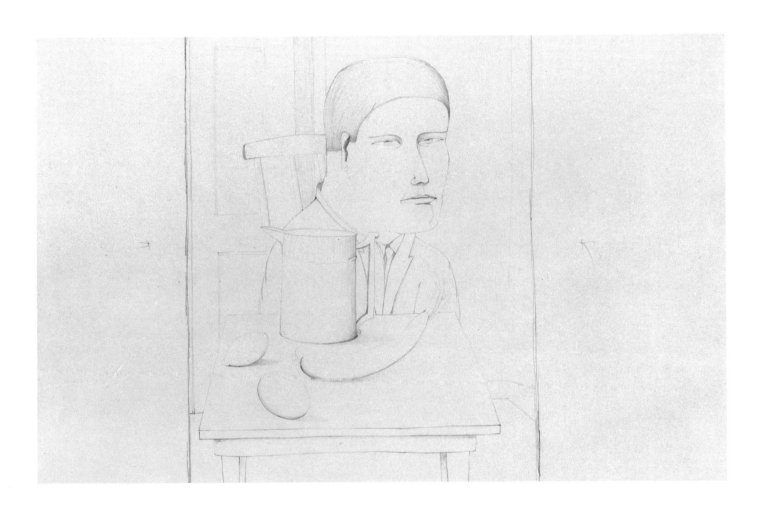

Drawing for *Self-Portrait*
c. 1947
Pencil
15 x 11½ inches
Unsigned

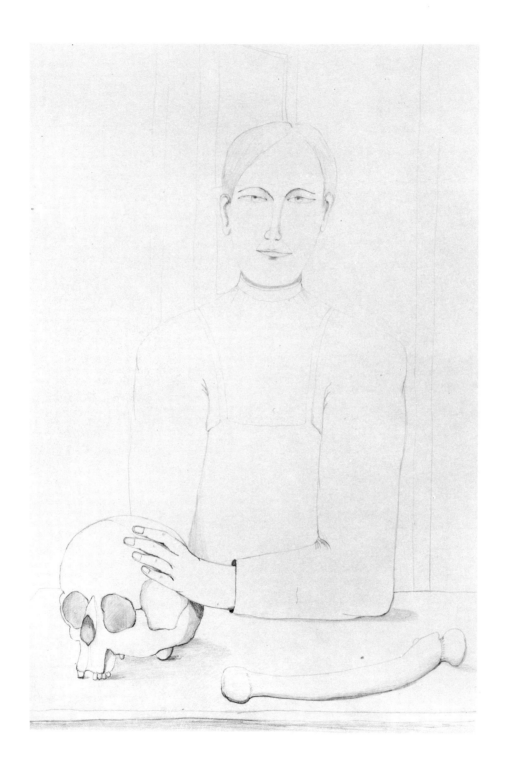

Drawing for *Figure with Skull*
c. 1947
Pencil
22 x 15 inches
Unsigned

56

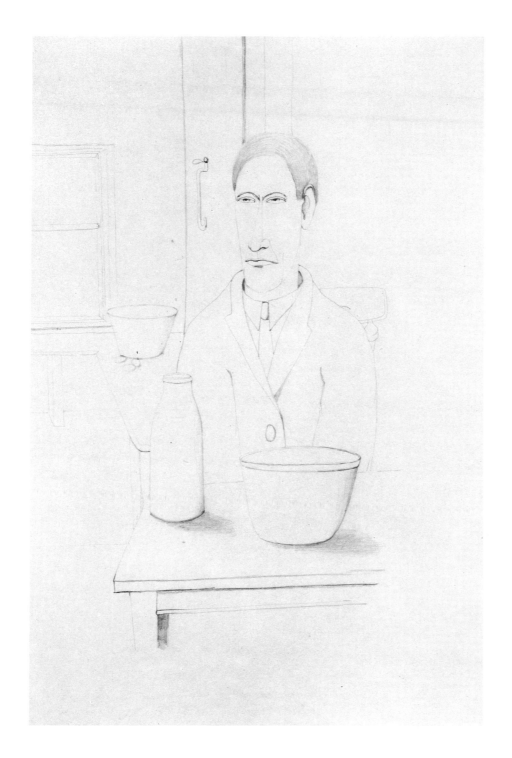

Drawing for *Self-Portrait and Still Life*
c. 1947
Pencil
22 x 14⅞ inches
Unsigned 57

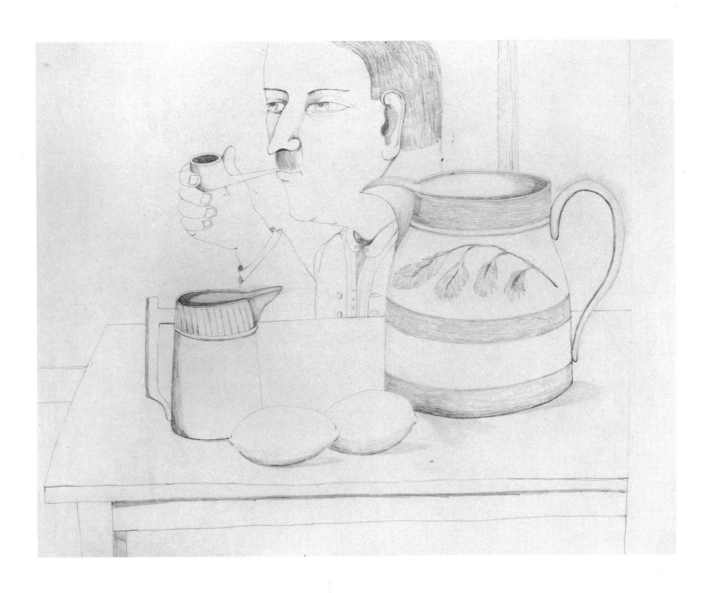

Drawing for *Man with Pipe and Still Life*
c. 1947
Pencil
20⅛ x 24½ inches
Unsigned

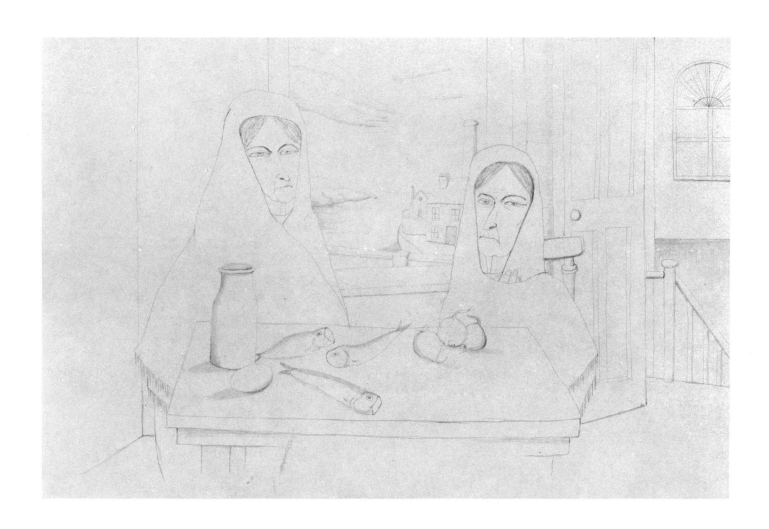

Drawing for *Two Women and Still Life*
c. 1946
Pencil
15 x 22 inches
Unsigned

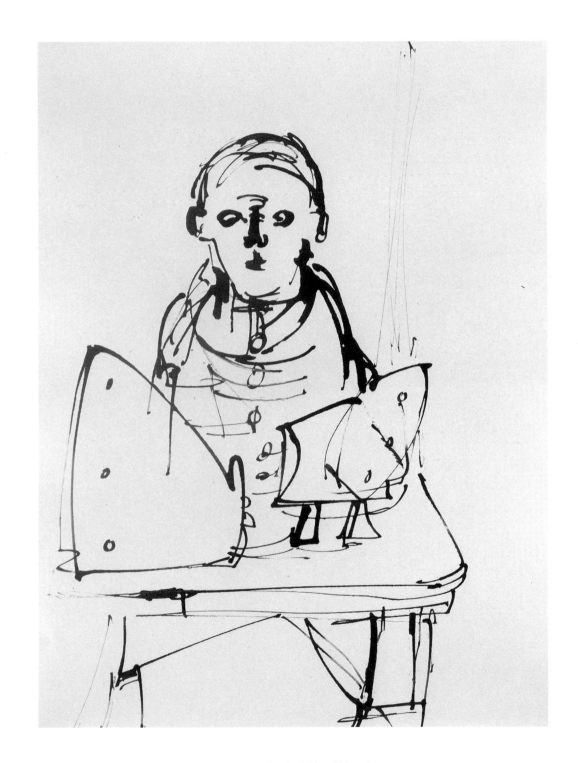

Pages from the two 'black' sketchbooks, pen and ink, 11¼ x 8½ inches

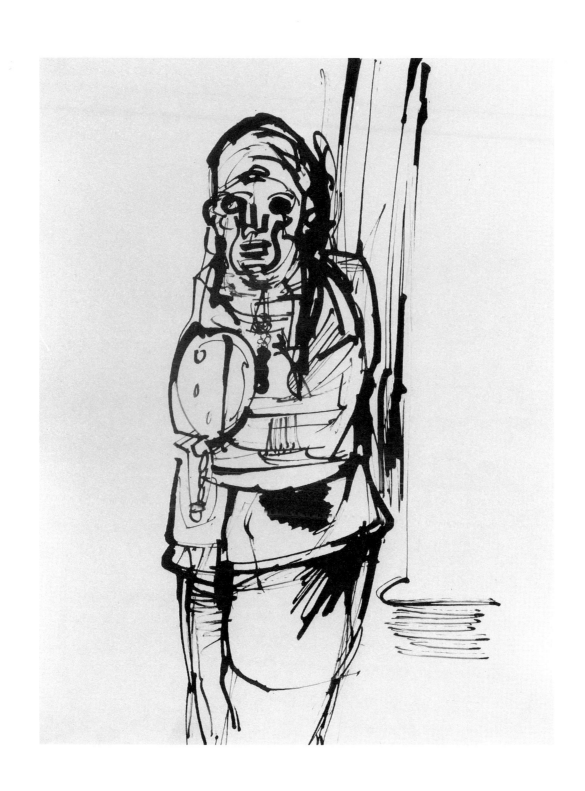

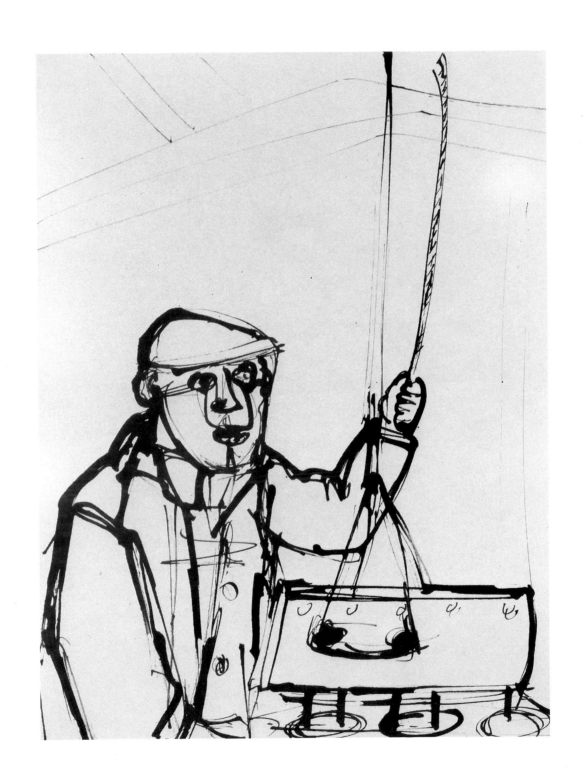

OIL PAINTINGS

In the Bath
1945
Oil on canvas
22⅛ x 16⅛ inches
Signed lower right

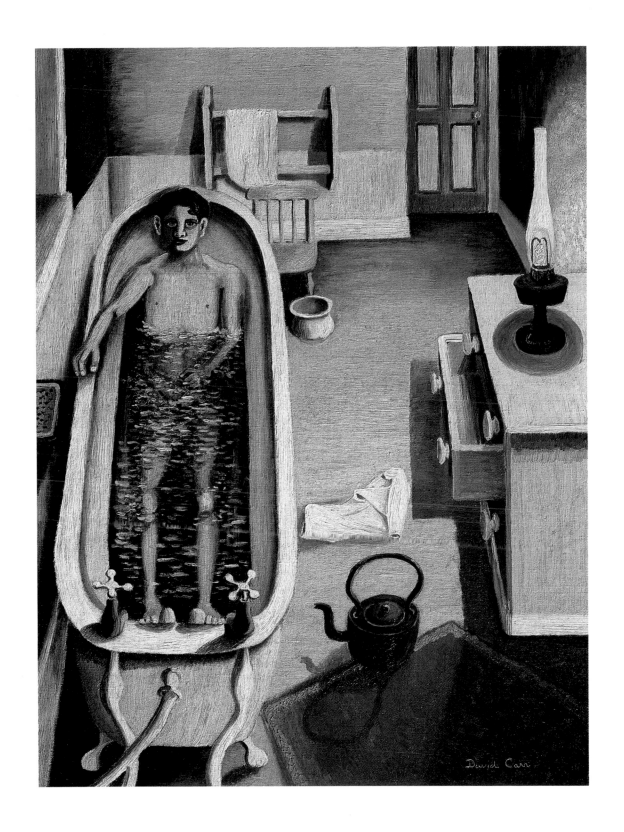

Feeding the Donkey
1945
Oil on canvas
21¾ x 25½ inches
Signed lower left

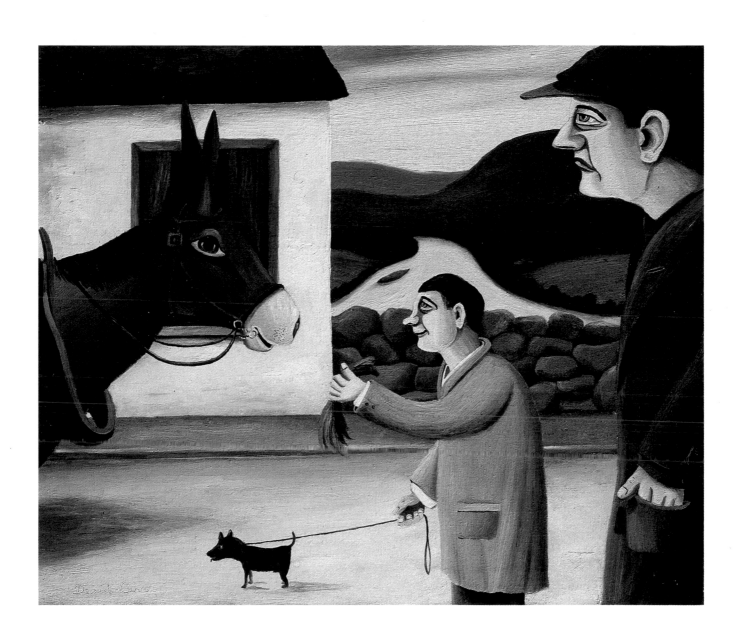

Small Head
c. 1946
Oil on canvas
13 x 11 inches
Signed with initials lower right

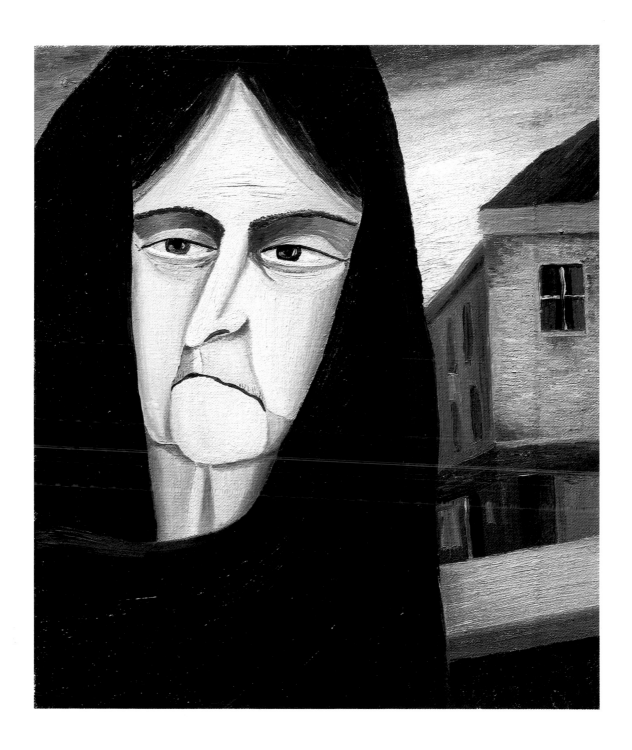

Two Figures and Still Life
c. 1946
Oil on canvas
23 x 33⅞ inches
Signed lower left

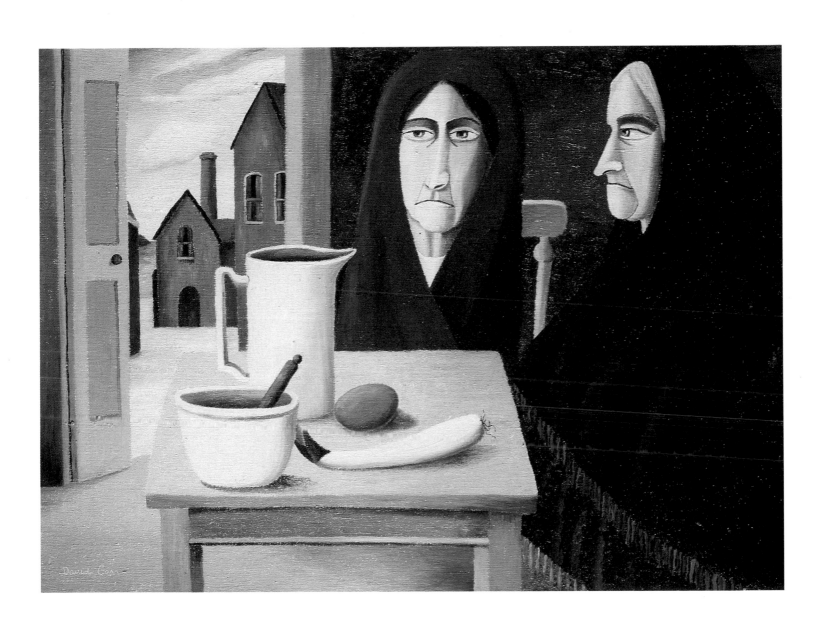

Two Women and Still Life
c. 1946
Oil on canvas
35 x 50 inches
Signed lower left

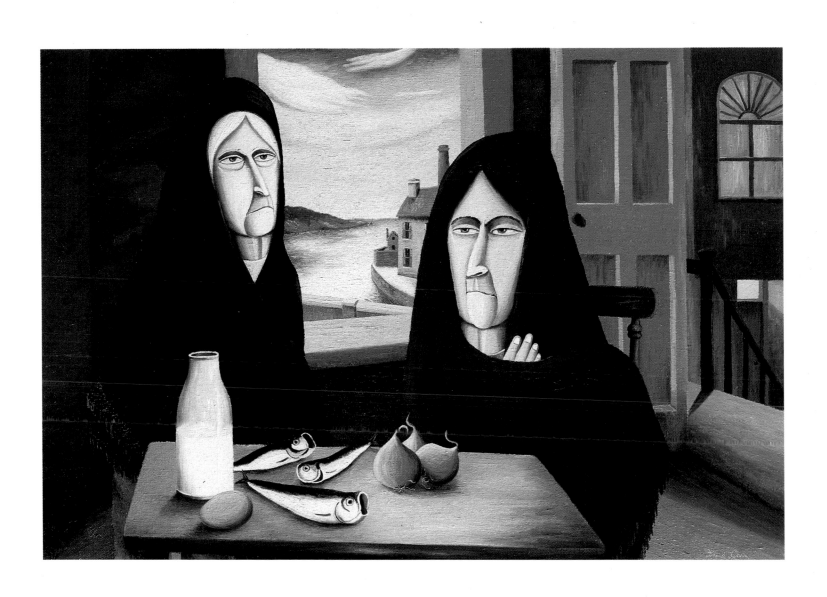

Two Women with Fish, Egg and Bottle
c. 1946
Oil on canvas
30 x 25 inches
Signed lower right

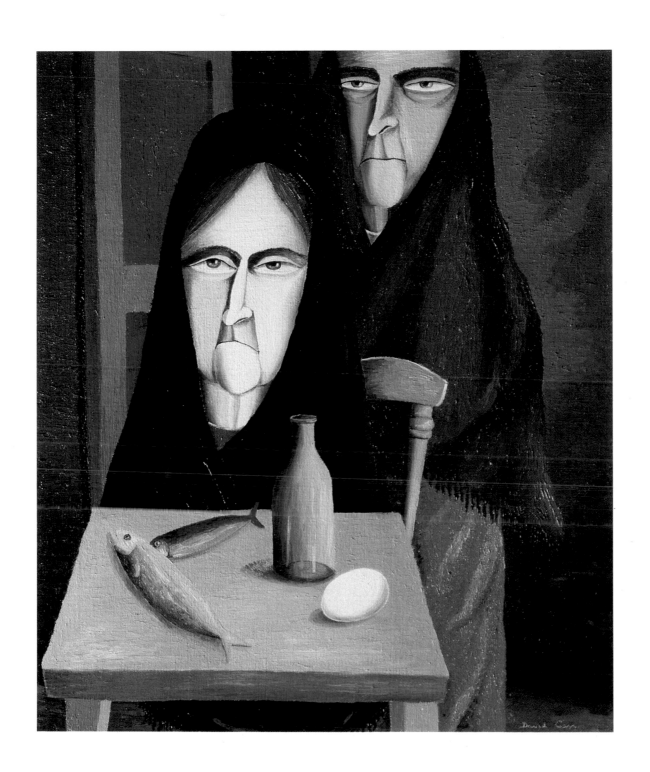

Figure with Skull
c. 1947
Oil on canvas
30½ x 21 inches
Signed on lower right

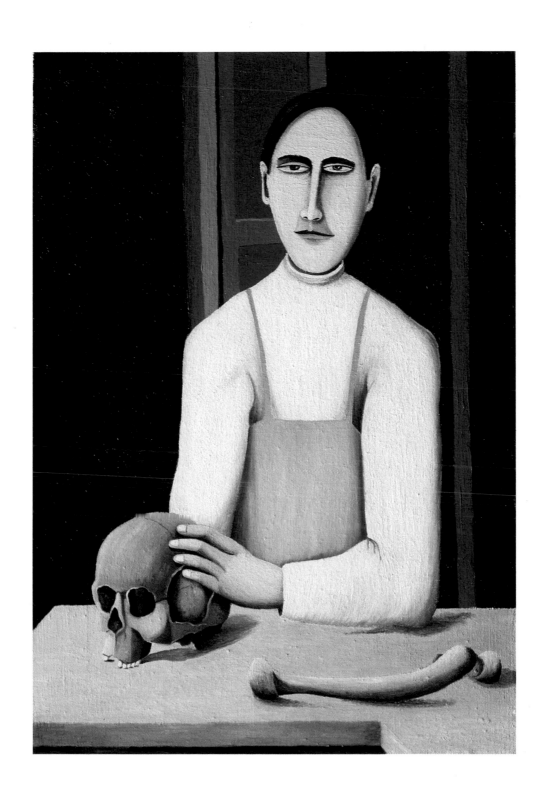

Self-Portrait
c. 1947
Oil on canvas
30 x 23¼ inches
Signed lower right

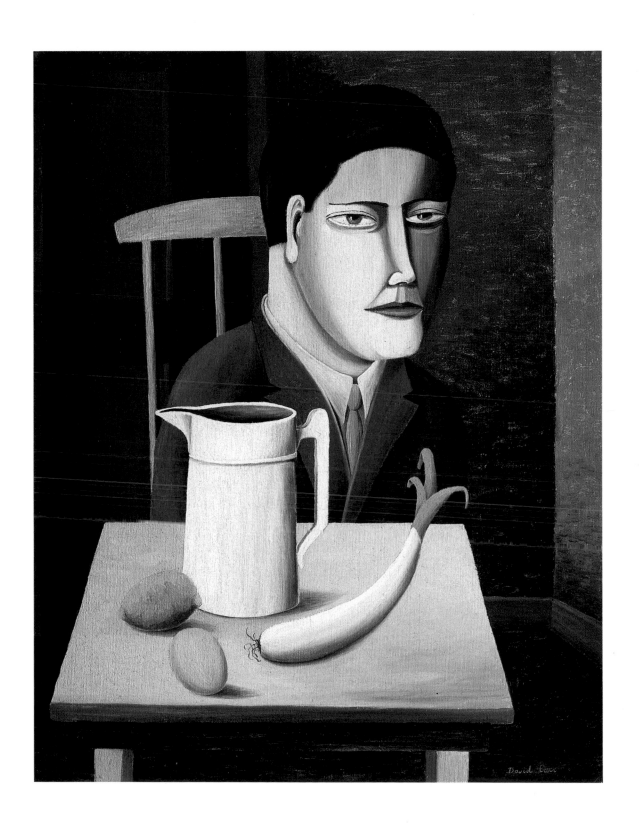

Self-Portrait and Still Life
c. 1947
Oil on canvas
33¼ x 24⅞ inches
Signed lower right

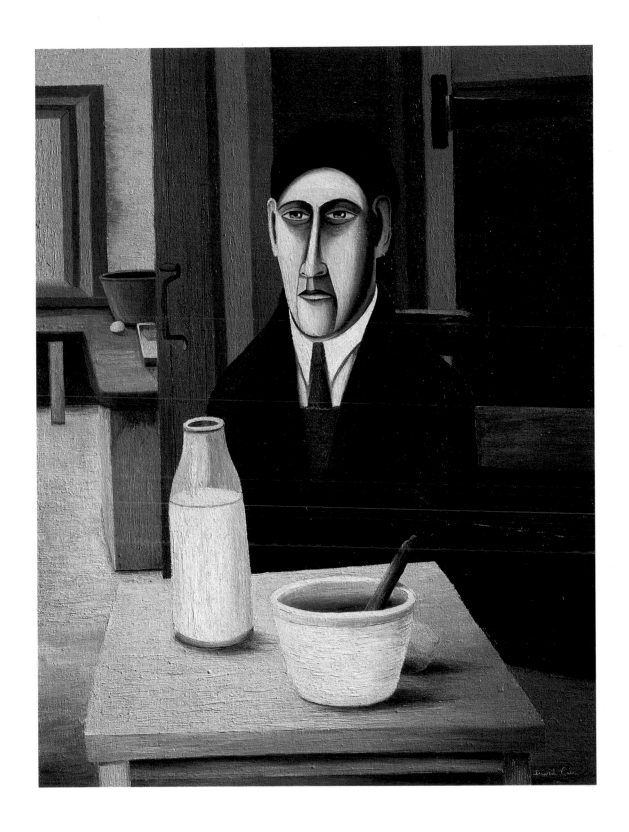

Man with Pipe and Still Life
c. 1947
Oil on canvas
20 x 23⅞ inches
Signed lower right

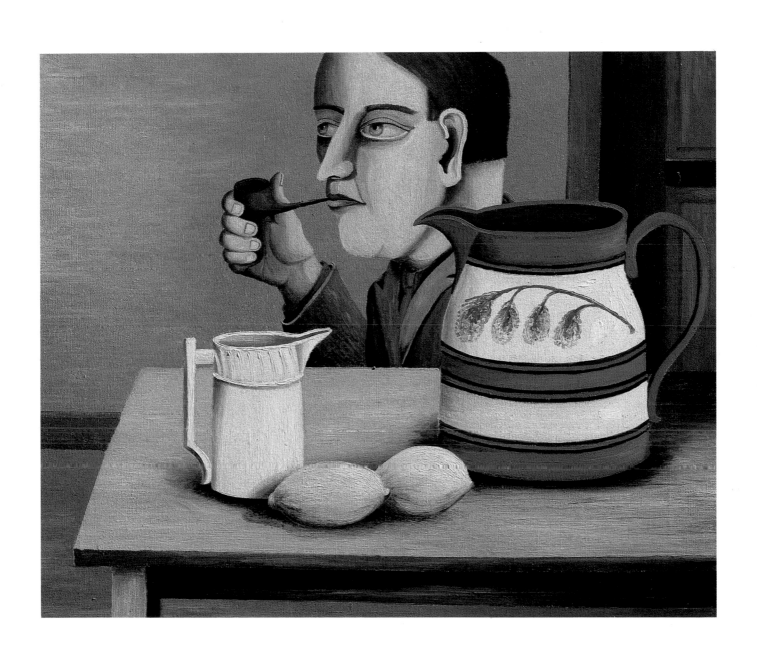

The Fishmonger and Family
c. 1948
Oil on canvas
25⅛ x 29⅞ inches
Signed lower left

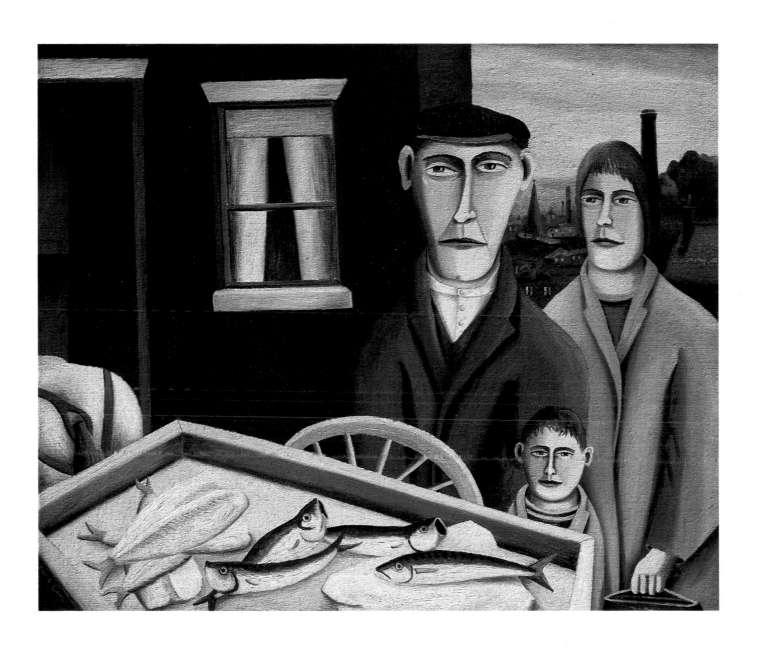

Three Figures and Fish
c. 1948
Oil on canvas
18½ x 24½ inches
Signed lower right

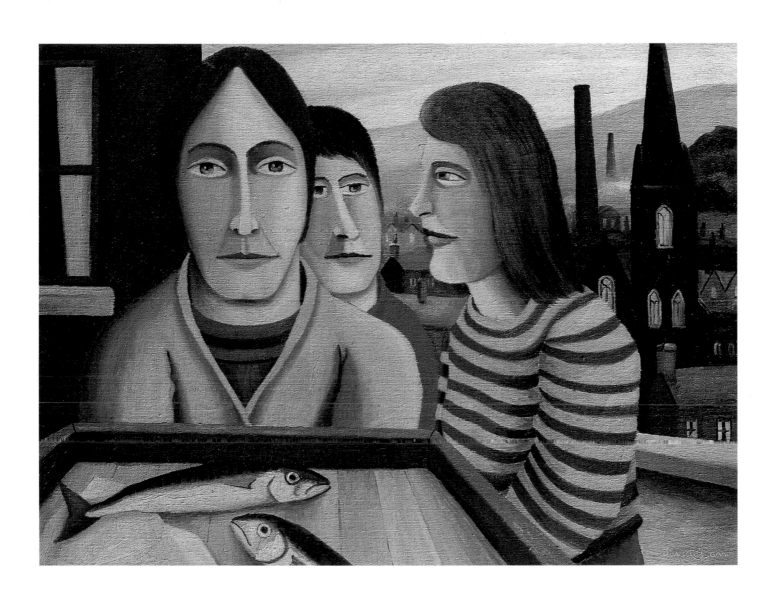

Fisherwomen Salting Herring
c. 1949
Oil on canvas
20 x 24 inches
Signed lower left

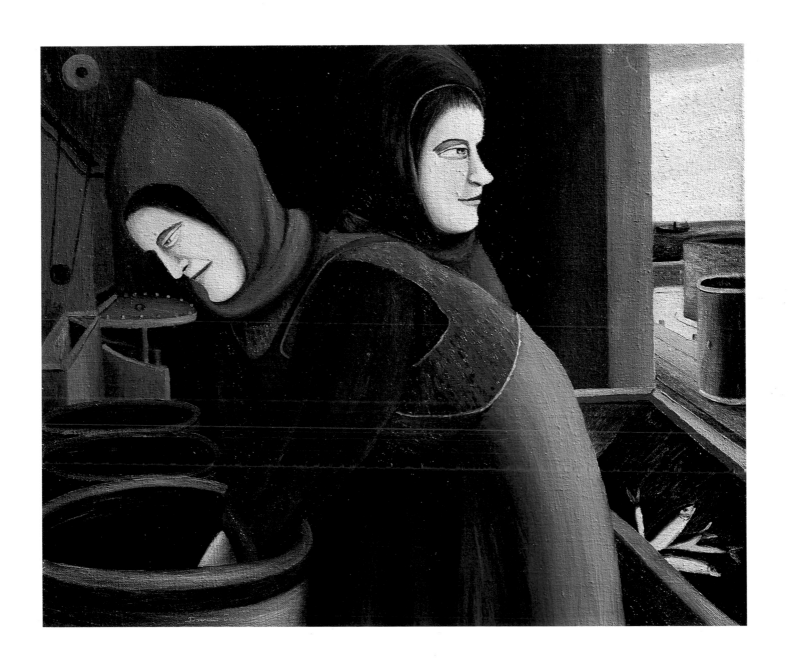

Fisherwomen Salting Herring
c. 1949
Oil on canvas
23 x 30 inches
Signed lower right

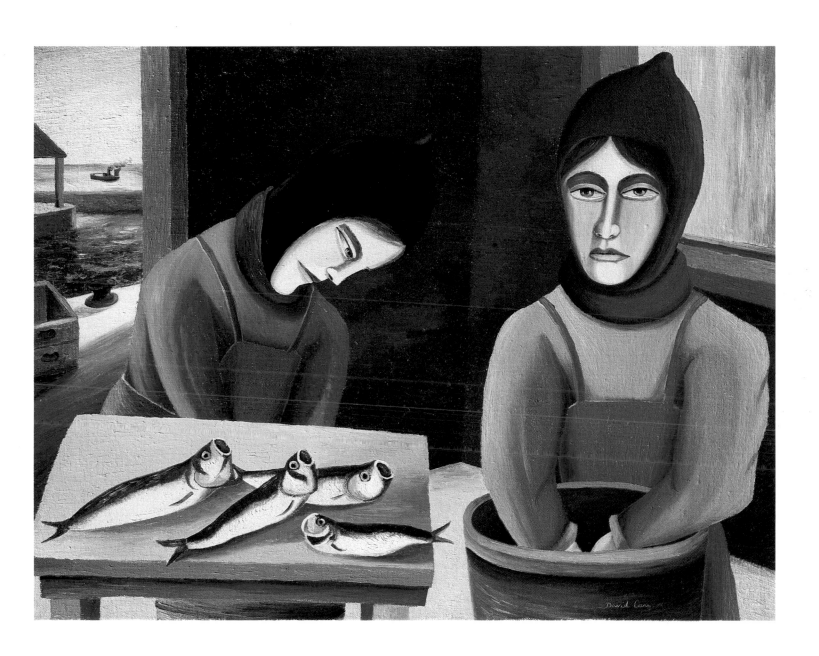

Cleaning the Nets
Lowestoft
c. 1949
Oil on canvas
24¼ x 30 inches
Signed lower left

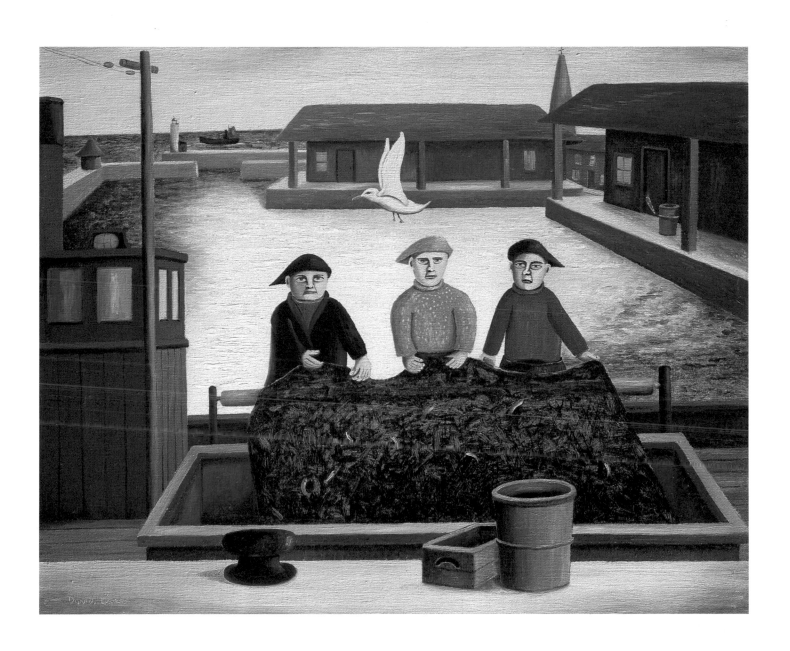

The Artist's Family
c. 1949
Oil on canvas
27¾ x 30⅞ inches
Signed lower left

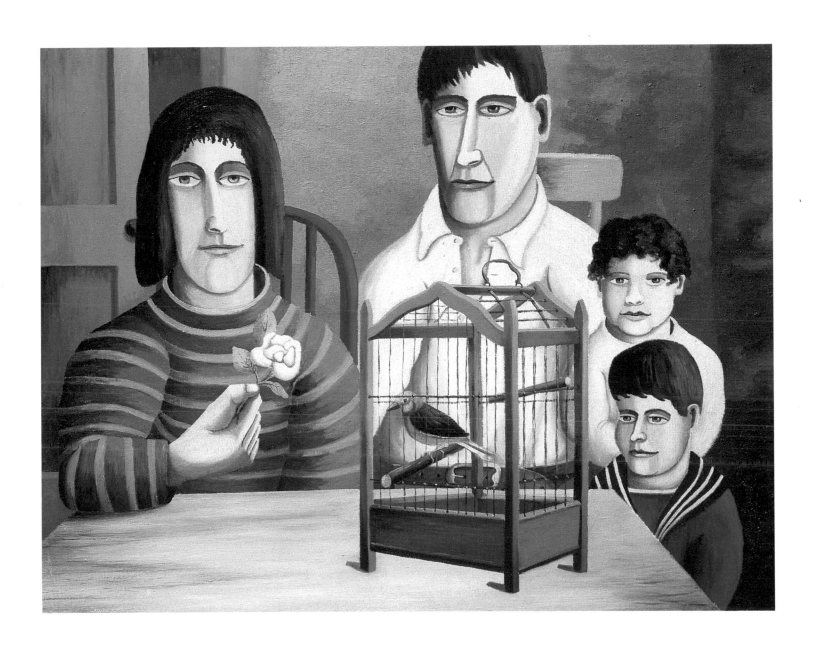

Biscuit-factory Workers
c. 1949
Oil on canvas
20 x 30⅛ inches
Signed lower centre

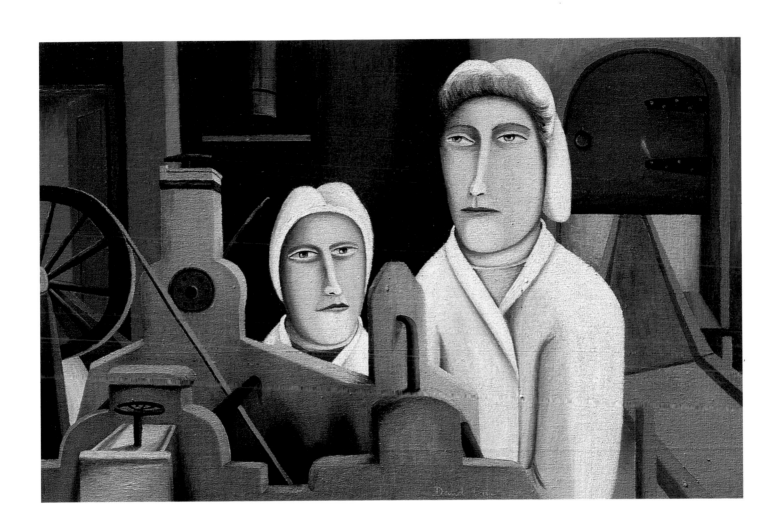

Dough Mixer
1950
Oil on canvas
30 x 25 inches
Signed lower right

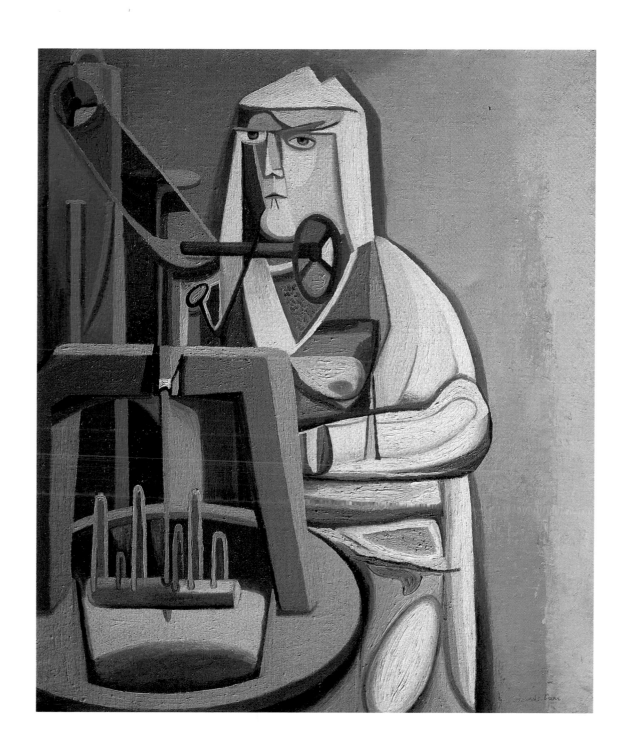

Man and Machine I
c. 1951
Oil on canvas
24 x 20 inches
Unsigned

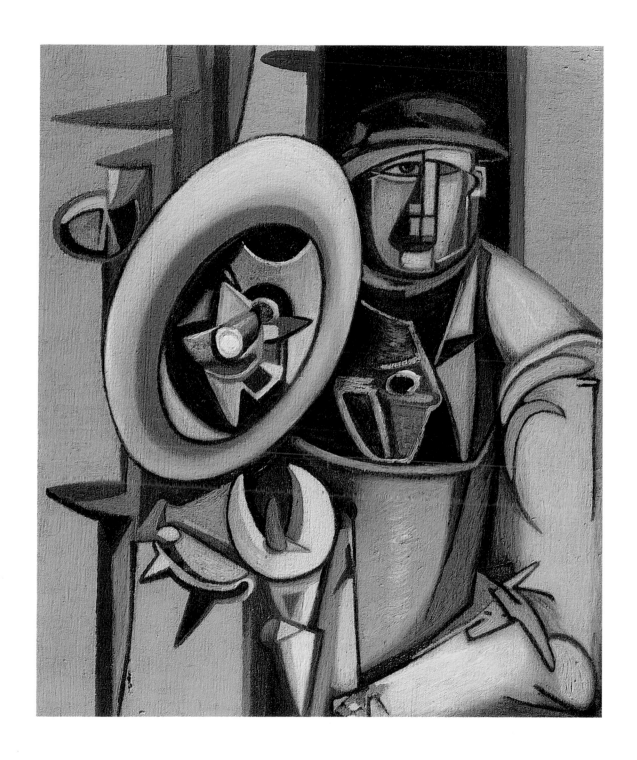

Man and Machine II
c. 1951
Oil on canvas
23⅞ x 18½ inches
Signed lower right

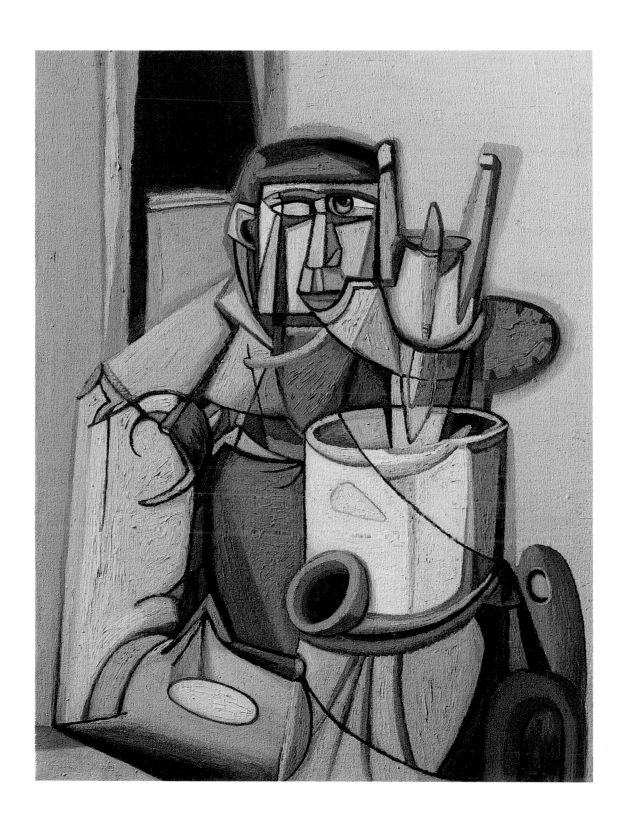

Man and Machine III
c. 1951
Oil on canvas
20 x 23⅞ inches
Signed lower left

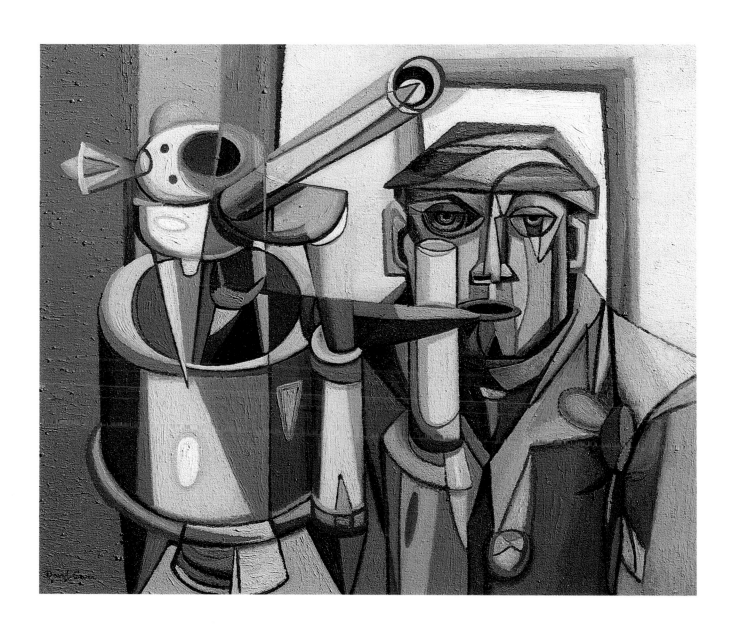

Man and Machine IV
c. 1952
Oil on canvas
24 x 19⅝ inches
Signed lower left

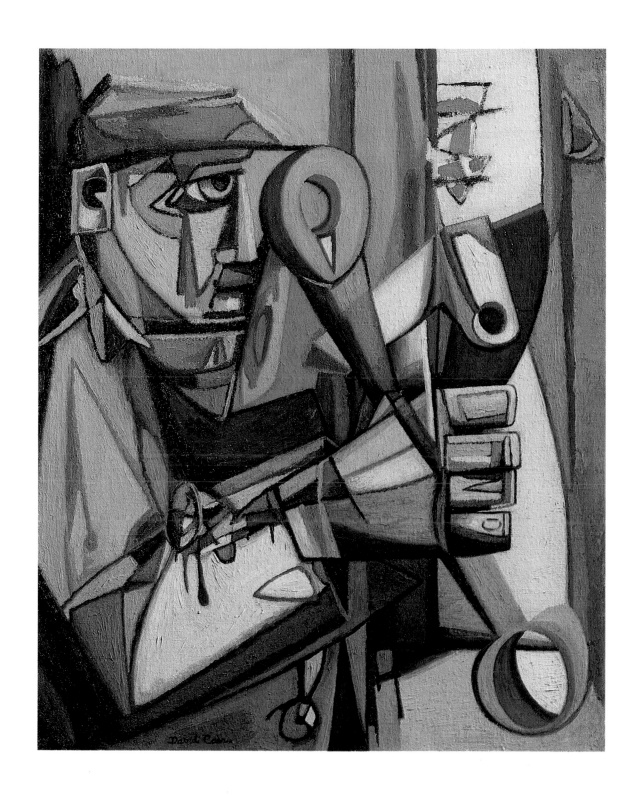

Man and Machine V
1952
Oil on canvas
24 x 20 inches
Unsigned

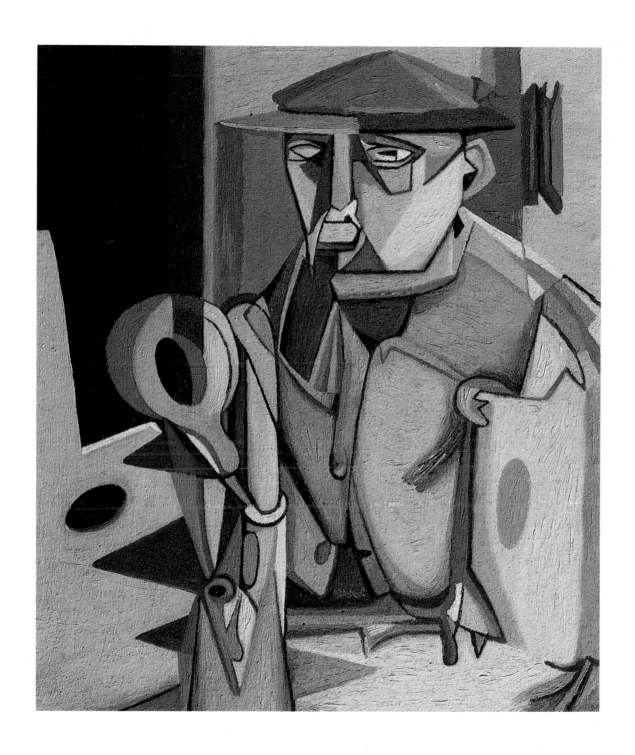

Man and Machine VI
c. 1952
Oil on canvas
23⅞ x 20⅛ inches
Signed lower right

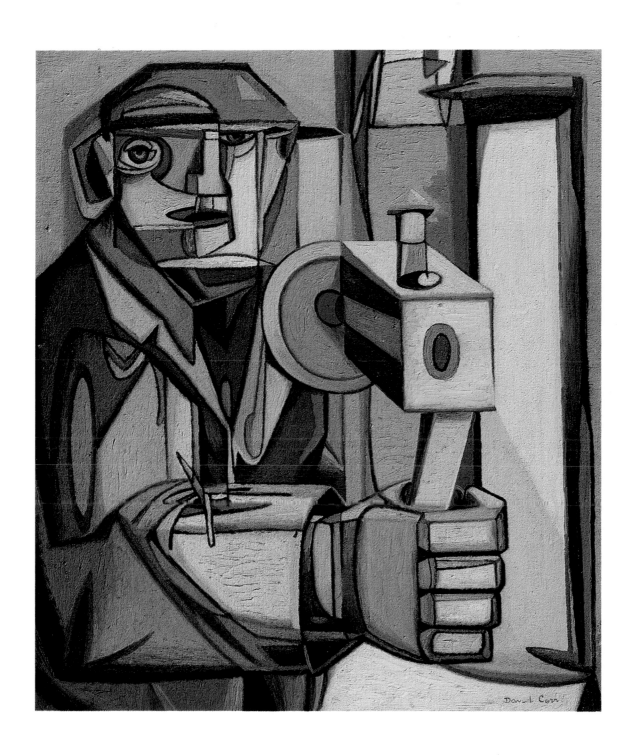

Man and Machine VII
c. 1952
Oil on canvas
21¾ x 18¼ inches
Signed lower left

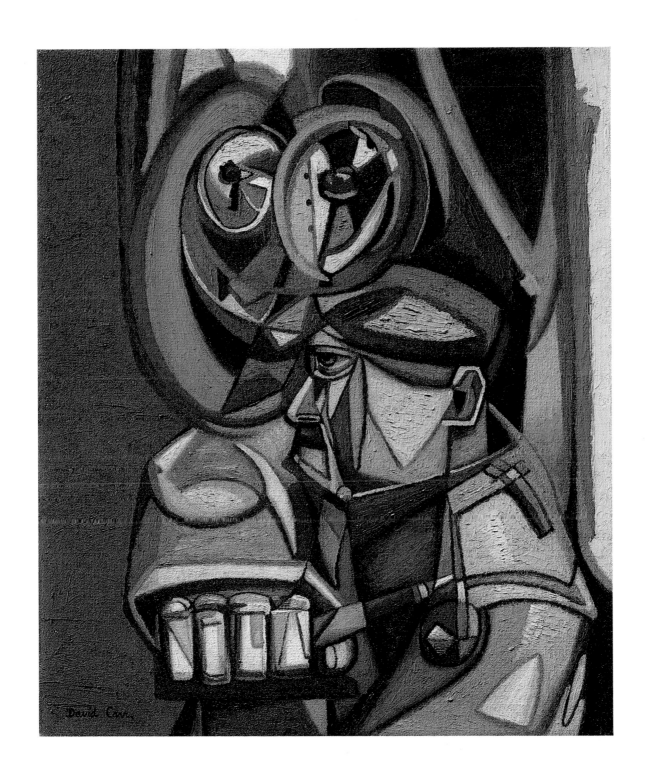

Man and Machine VIII
c. 1953
Oil on canvas
24 x 20 inches
Signed lower left

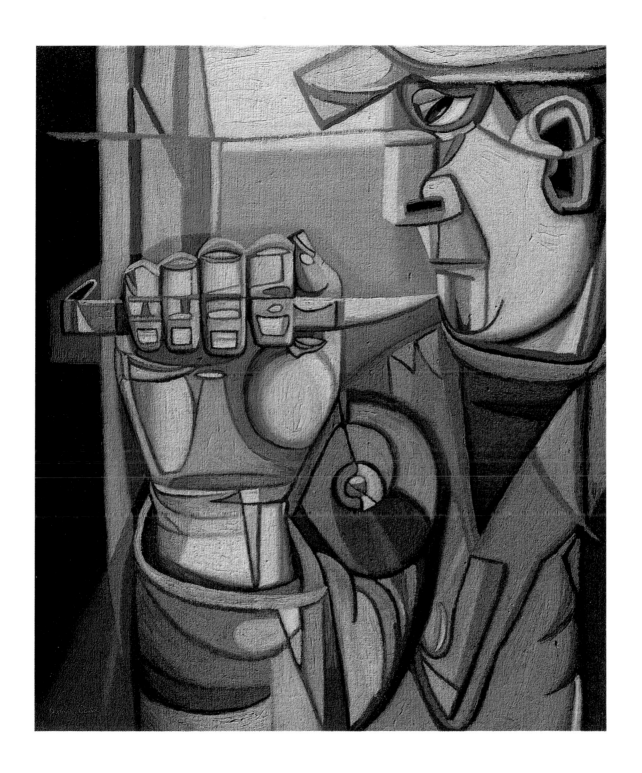

Man and Machine IX
c. 1953
Oil on canvas
24 x 20 inches
Signed lower right

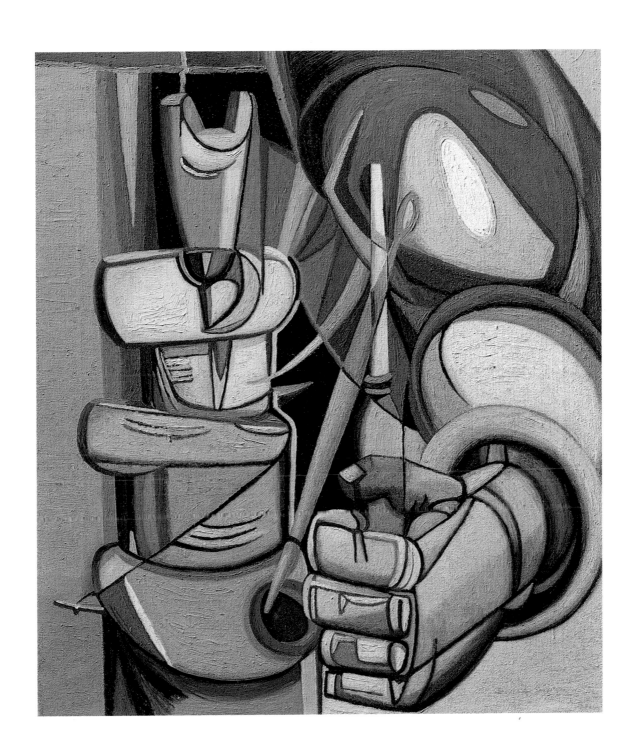

Man and Machine X
c. 1953
Oil on canvas
26 x 18 inches
Signed lower right

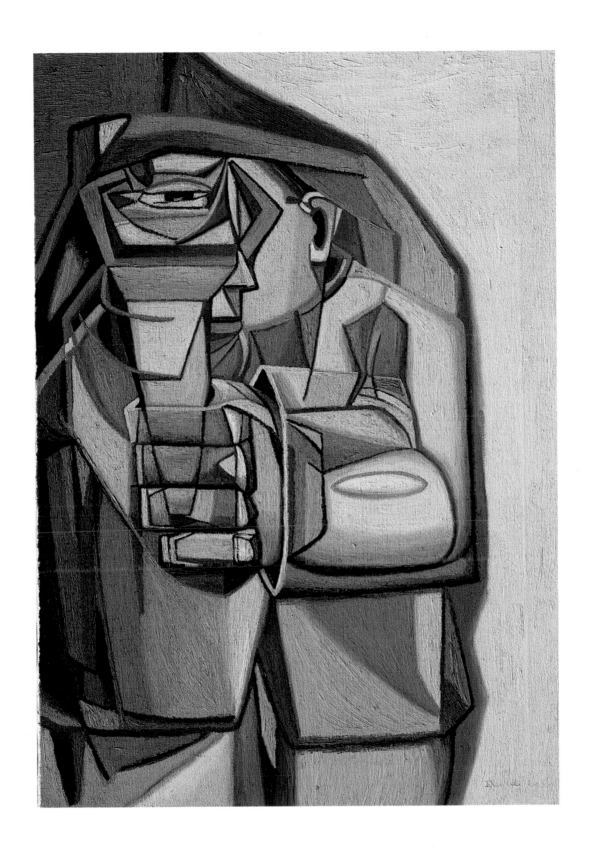

119

Man and Machine XI
c. 1953
Oil on canvas
23 x 23⅞ inches
Unsigned

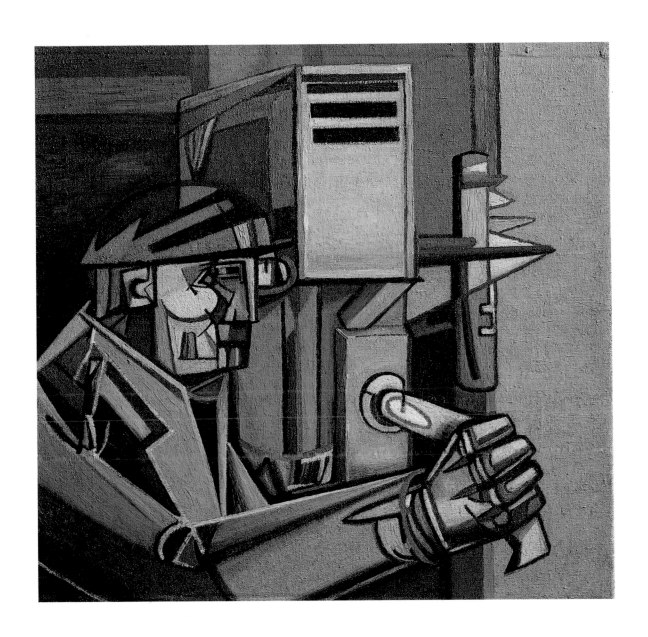

Man and Machine XII
c. 1954
Oil on canvas
26⅞ x 21⅞ inches
Signed lower centre

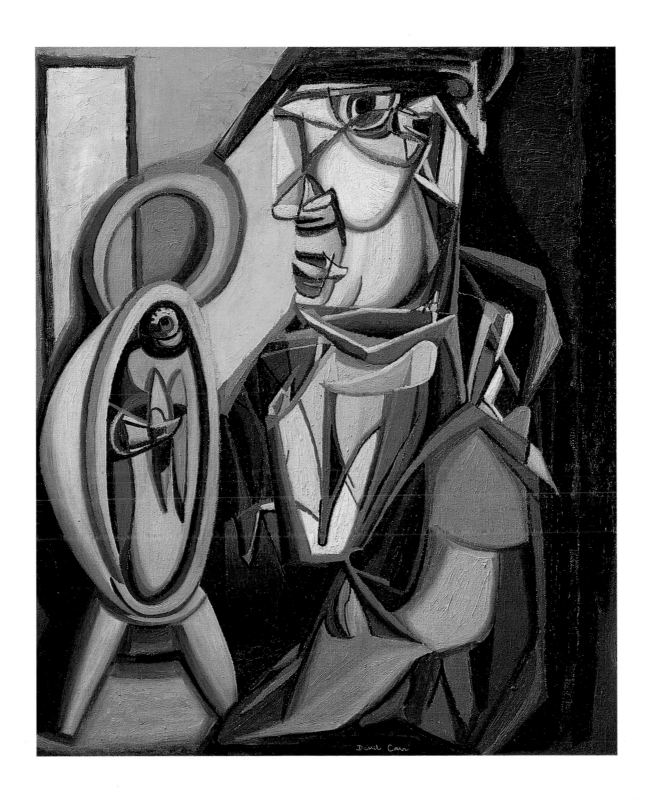

Man and Machine XIII
c. 1954
Oil on canvas
20 x 24 inches
Unsigned

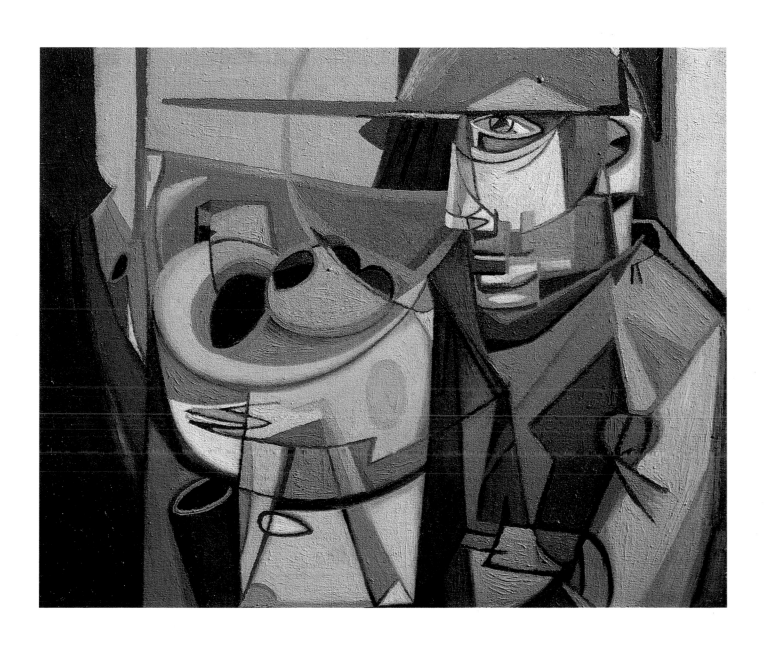

Man and Machine XIV
c. 1954
Oil on canvas
20 x 24 inches
Unsigned

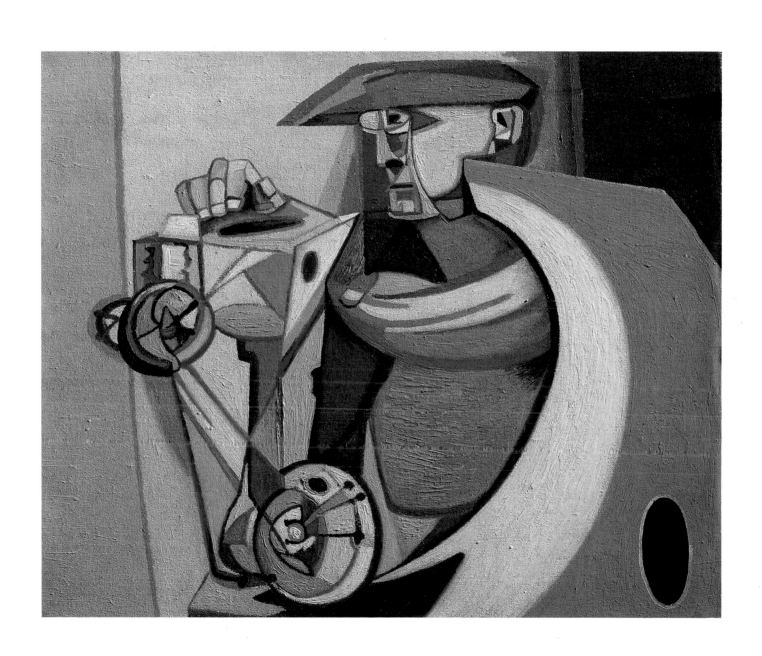

Man and Machine XV
c. 1955
Oil on canvas
30 x 20 inches
Unsigned

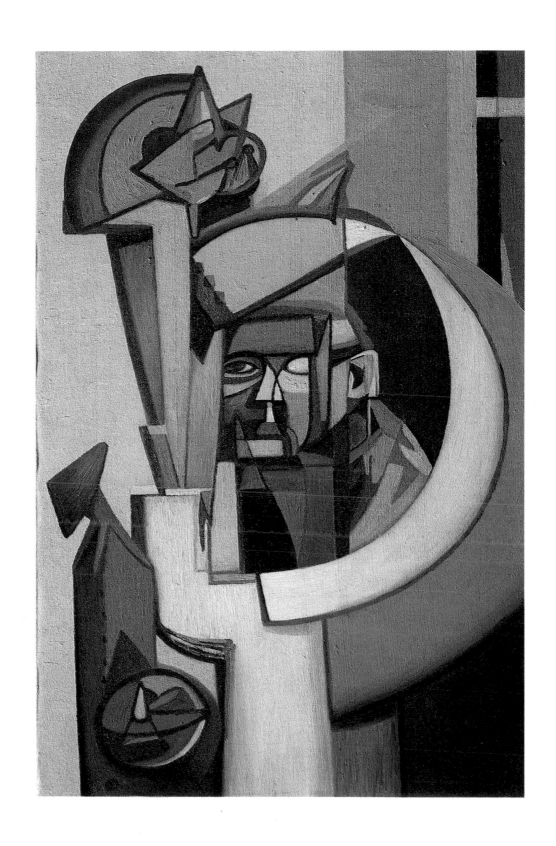

Man and Machine XVI
c. 1955
Oil on canvas
23⅝ x 28⅞ inches
Unsigned

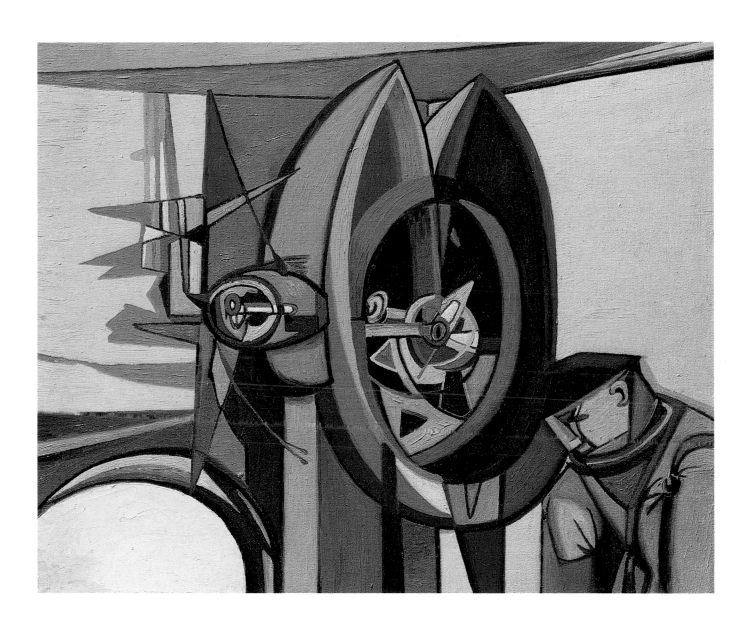

Man and Machine XVII
c. 1955
Oil on canvas
30 x 20 inches
Unsigned

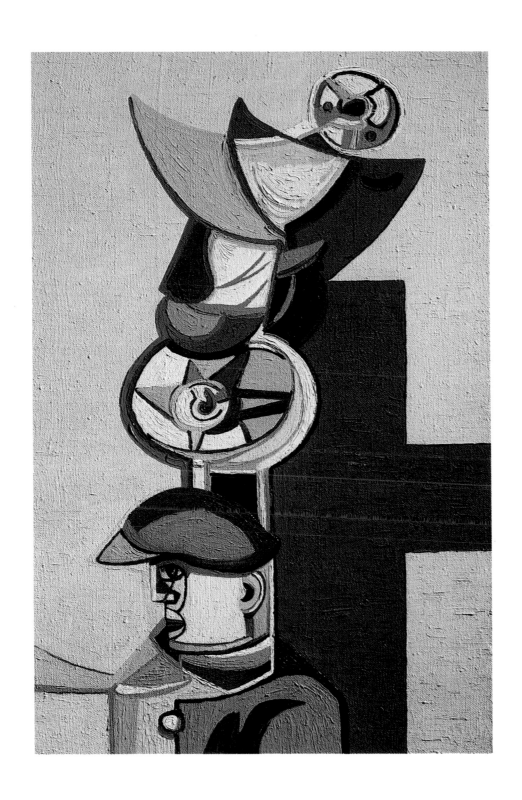

Man and Machine XVIII
c. 1955
Oil on canvas
38 x 28⅝ inches
Unsigned

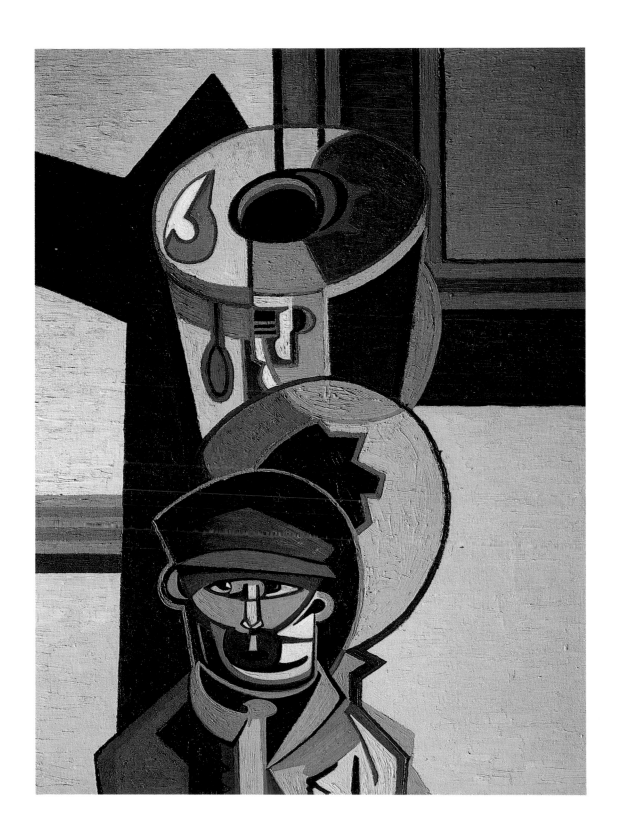

Man and Machine XIX
c. 1955
Oil on canvas
38 x 32 inches
Unsigned

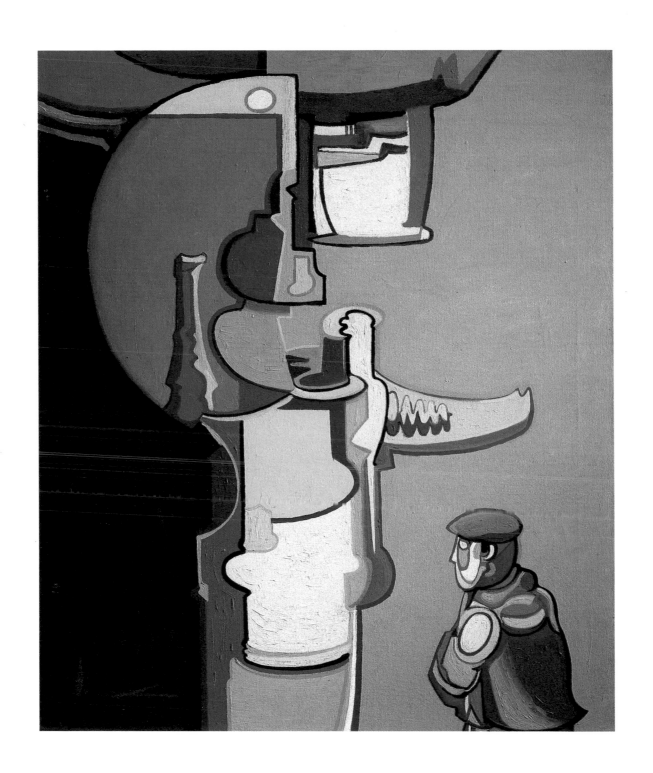

Man and Machine XX
c. 1956
Oil on canvas
36¾ x 29⅛ inches
Unsigned

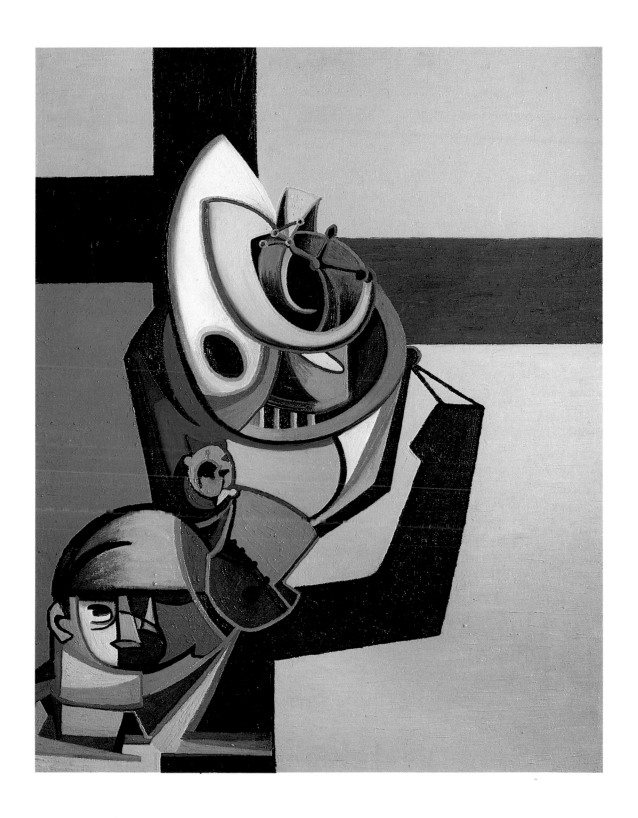

Man and Machine XXI
c. 1956
Oil on canvas
25 x 27⅞ inches
Unsigned

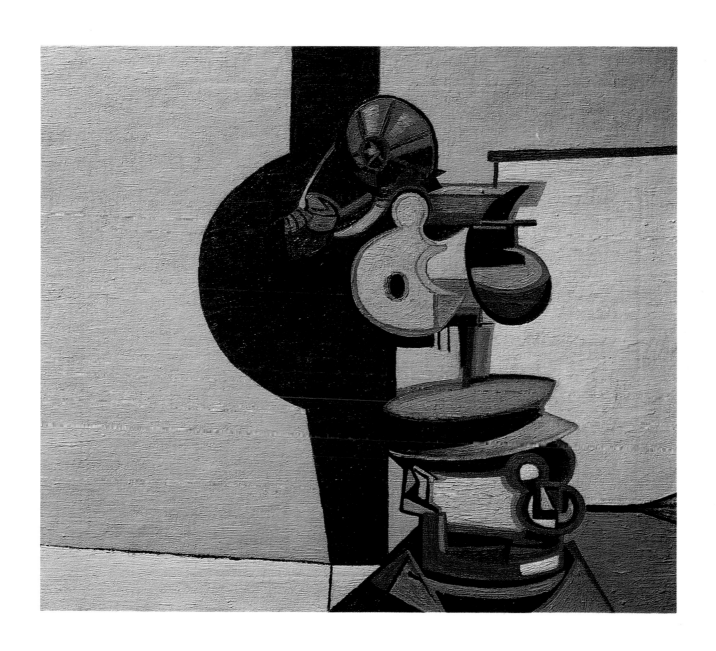

Man and Machine XXII
c. 1956
Oil on canvas
29⅞ x 20⅛ inches
Unsigned

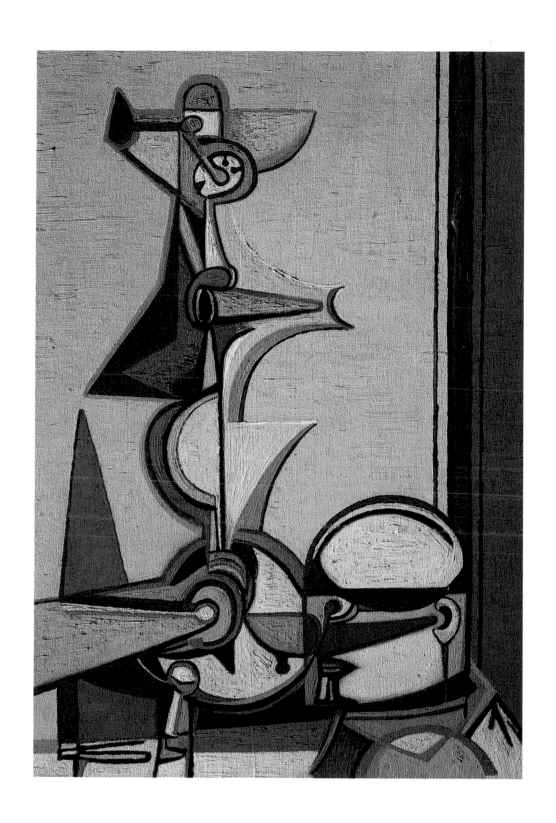

Man and Machine XXIII
c. 1957
Oil on canvas
20 x 24 inches
Unsigned

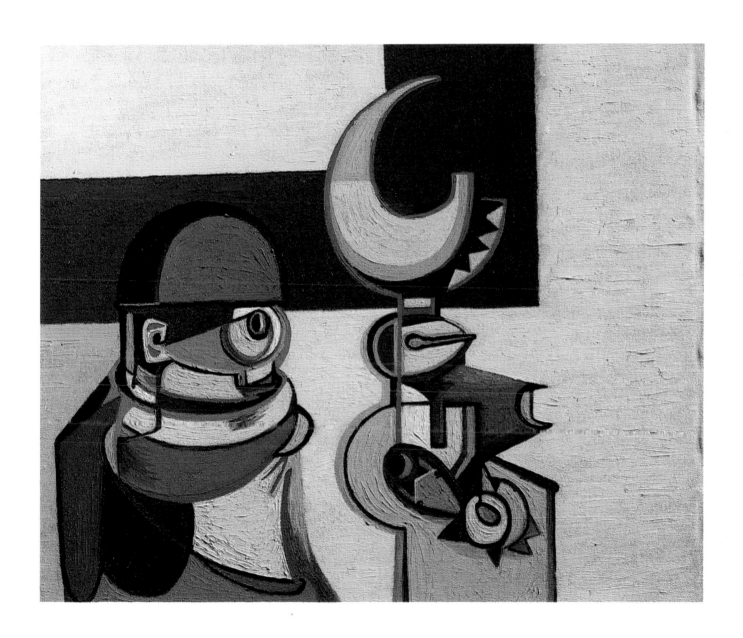

Drawing – *Studies*
c. 1958
Charcoal and watercolour
Sheet size 9 x 11½ inches
Unsigned

Drawing – *Studies*
c. 1959
Pen and watercolour
Sheet size 9 x 11½ inches
Unsigned

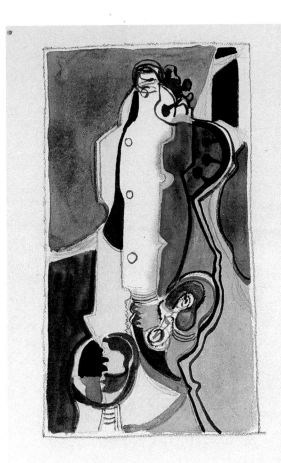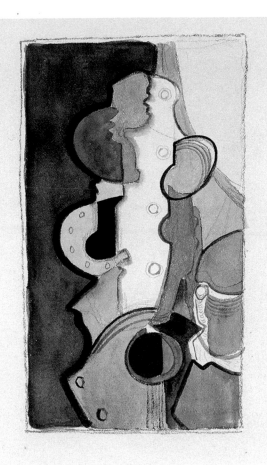

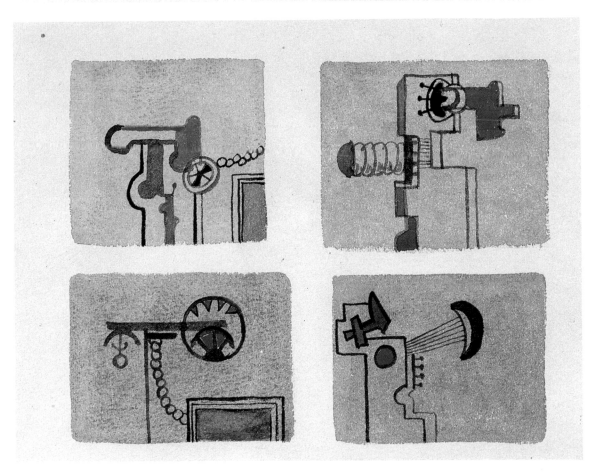

147

Drawing – *Studies*
c. 1959
Pen, charcoal and watercolour
Sheet size 9 x 11½ inches
Unsigned

Drawing – *Studies*
c. 1959
Pen, charcoal and watercolour
Sheet size 9 x 11½ inches
Unsigned

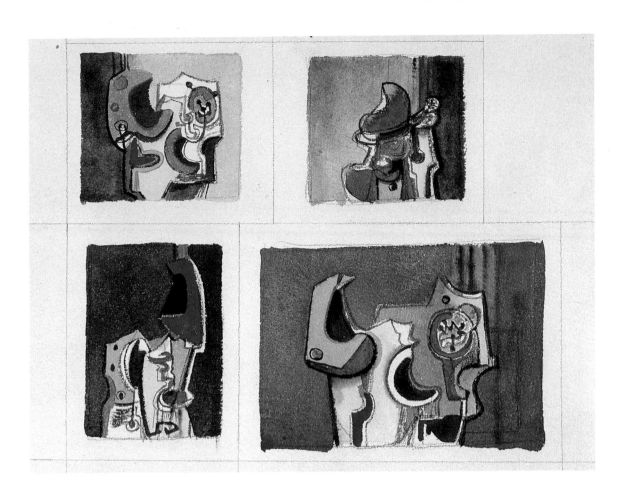

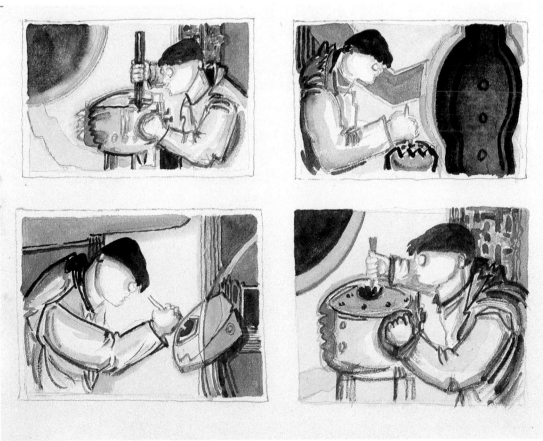

Drawing – *Studies*
c. 1960
Watercolour
Sheet size 9 x 11½ inches
Unsigned

Drawing – *Studies*
c. 1960
Watercolour
Sheet size 9 x 11½ inches
Unsigned

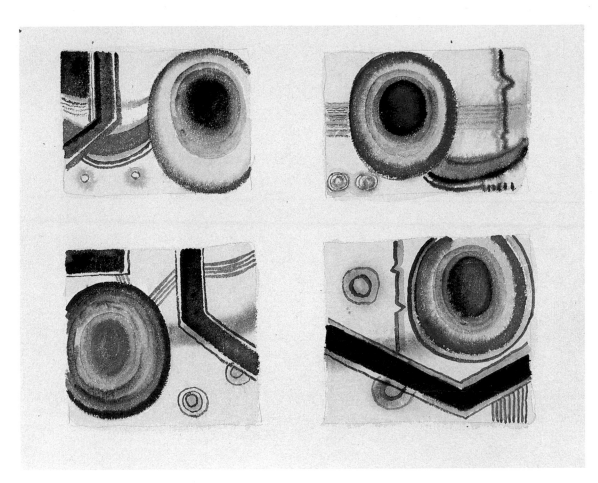

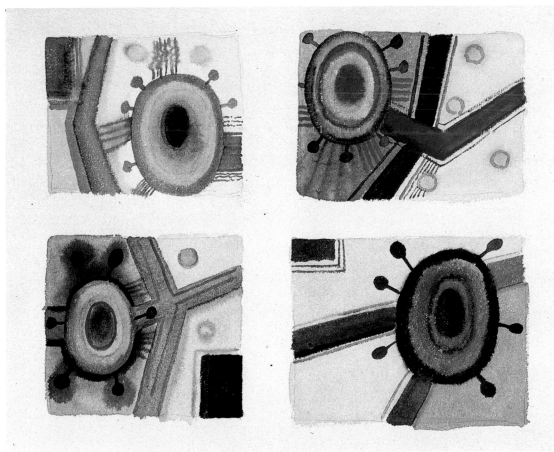